Charles Dickens

GREAT EXPECTATIONS

Adapted for the stage by Neil Bartlett

OBERON BOOKS
LONDON

Staging Dickens

Underneath that conveniently tautological hold-all of an adjective 'Dickensian', there is an extraordinary range of tones and qualities in the man's work. For all that its plot has the outline and mechanics of a classic mystery, the retrospective first-person narrative of *Great Expectations* gives it an interior quality – a particularly damaged, guilty kind of melancholy – that is a long way away from, say, the lurid theatrical excitements of *Oliver Twist*, or the incomparably confident 'tuppenny coloured' economy of *A Christmas Carol*.

In large part, this particular tone springs from the fact that the novel's plot is rooted in the dark heart of Dickens' own life; it digs as deeply into his favourite theme of the abandoned child as anything he ever wrote. Pip, the archetypal orphan, is surrounded by surrogate family – parents: Joe, Mrs Joe, Biddy; uncles: Jaggers and Pumblechook; brothers: Herbert – and in finding forgiveness in his heart for both Miss Havisham and Magwitch, he has finally to come to terms with perhaps the most memorably terrifying Bad Mother and Bad Father in all of English prose fiction. In the process of doing so, he is moved as much by anger as by guilt – Pip has the most terrible temper – and inflicts (on his author's behalf) truly dreadful deaths on the mother- and father-figures whom he holds responsible for his betrayals and sorrows. In the original novel, the punishment handed out to Mrs Joe, for instance, for her bringing-up of her brother 'by hand', is callous to the point of authorial brutality.

This depth of emotion presents anyone who wants to convey their admiration for this magnificent novel to a theatre audience with some specific problems. How can a language for actors – which must always be capable of moving swiftly – be quarried out of a book which orchestrates its emotional themes with the same slow force as the river that runs through it? And how, in particular, is one to deal with the fact that Pip is so fond of telling us exactly what he is feeling – something which one is reliably informed that actors, in general, should always be advised to avoid? Well...

TALKING TO THE AUDIENCE

This adaptation assumes that the actors – especially the actor playing Pip, but also the actors of the company which both colludes with him and conspires against him in its re-enactment of his memories – take the audience into their confidence even before the first line of the evening is spoken. This can be justified either as an allusion to the melodramatic conventions of the Victorian theatre which Dickens so loved, or as an up-to-date deployment of the marvellous rediscovery made by several 'physical theatre' companies and practitioners in recent decades – namely, that establishing collusion with the audience is always a prerequisite for good storytelling.

CHARACTER

In Dickens, it's perhaps not so much a question of character, as of characteristics – anyway, for him, the two are inseparable. To capture the physical rhythms of the characters, I have wherever possible employed Dickens' original lines; but inevitably, the actors of this piece will help themselves a great deal if they acquaint themselves with all the descriptions of actions and inflections that, if they had been included here as stage directions, would have made the script at least as twice as long as it is. Sometimes, it is a question of noticing quite subtle things – Estella's arch calm, or her ability to be always 'gliding away'; Pip's characteristic flares of temper; Herbert's light, tripping, tender breathiness; the way in which Miss Havisham's language moves between smouldering – slow, subterranean, ashen – and blazing – sudden, ferocious, wild. Sometimes, it is a question of being prepared to steal, wholesale, such gifts to the actor as Dickens' description of Sarah Pocket when she first sees Pip dressed a gentleman: 'Miss Pocket positively reeled back when she saw me so changed; her walnut-shell countenance likewise turned from brown to yellow to green.' There's at least one of those on every page...

On first reading, I'm sure that it will seem that some of the most important emotional geography (of the second half of the story especially) is either obscure, or just plain absent.

For instance, Pip's great struggle with how much he loathes Magwitch's hold over him, and with how hard he finds it to return Joe's love, are, apparently, barely hinted at in the written dialogue given here. To infuse the lines with their proper weight, I think the actors are going to have to be well acquainted with the novel. This is not just true of the big moments; for instance, (on another level of meaning entirely) the description of Wemmick's mouth as 'the letterbox' is surely the key to his whole character – tight, metallic, efficient, good with official papers and quite capable of snapping off your fingers. This reliance on acquaintance with the book is perhaps strongest in my writing of Mr Wopsle, which requires that anyone lucky enough to be cast in the part is going to have to condense the whole of Dickens' brilliant portrayal of the man's vanity, idiocy, condescension and self-theatricalising small-town frustration into a single, reiterated word, since that's more or less all I ever give him to say.

THE SETTING

The setting for any show is of course determined entirely by the budget; this script relies on the assumption that no one has been foolish enough to give the designer one big enough to build a succession of heavy, well-upholstered, location-specific fixed sets. On the contrary, it assumes that the story can move as fast as Dickens does from place to place. Any solution to this challenge will have to accommodate the two very different kinds of spaces in which Pip experiences his loneliness. Everyone remembers the marshes – the wide, desolate, sodden, river-haunted space in which the book opens, and which then brilliantly returns to reclaim Magwitch in his death by drowning amidst the mud and black waters of the Thames at Gravesend. This child-dwarfing landscape is set off against a series of subtly claustrophobic interiors, each of them claustrophobic for a different emotional reason: the Gargery kitchen; Jaggers' office; the strangely imprisoning rooms of Herbert's lodgings in Barnard's Inn and the bow-fronted house on the river where he temporarily conceals Magwitch – and, of course, the haunted labyrinth of Satis House itself.

Every production of this script must find its own solutions to how to stage this story, but it is probably worth mentioning two things which I noticed about its telling while working on this adaptation. The first is how Dickens uses light – in particular, how often he uses a single light source surrounded by darkness to isolate key moments or images of the story. Potent examples would be the torches which illuminate Compeyson's face out on the marshes; the candle with which Estella leads Pip through the darkness of Satis House; the light by which Pip is reading his book on the dark night when Magwitch returns; the firelight and candlelight – never daylight – which accompany Miss Havisham, and which of course finally consume her in the book's most terrifying variation on its overriding theme of illumination, of light-amidst-darkness. At the end, it seems somehow strangely characteristic of the story – and strangely satisfying – that the final scene doesn't replace all this darkness with blazing sunlight, but with a strangely ambiguous moonlight. Pip starts his story in a freezing fog – and ends it chilled by moonlight...

The second thing I noticed was how the story makes uses of recurrent sounds. The sound of metal on metal seems very important – files, chains, keys, locks, a blacksmith's hammer on an anvil. The echoing percussions of the guns on the marshes, of the fatal steamboat paddles, of various knockings on various doors – and of Pip's own beating heart – also appear and reappear at crucial points. Sometimes Dickens even seems to be making a sound a quite deliberate leitmotif; he specifies, for instance, that it is the very same wind that was blowing across the marshes when Magwitch first appeared that then travels vengefully up the Thames into the very heart of London on the night that he returns.

STAGE DIRECTIONS

The stage directions in this script were an attempt to make some of my intentions clear to the director of the very first production, for whom this script was commissioned. I would of course expect that any future directors and actors would ignore them entirely, and find their own way of doing things.

DOUBLING

This adaptation was written to be performed by a company of eight; I don't *think* it can be performed with less – though I'd love to see someone try. It could of course be performed by more. My only suggestion would be that the actor playing Pip should never double, and that all the actors not playing Pip should; there seems to me to be something essential about the dynamic of Pip-versus-the-world, Pip-aided-and-abetted-by-the-company as they re-enact his dreams and memories.

Some of the doubling proposed for the first production had its own emotional logic. There is (I hope) something satisfying about the parental double-act of Joe and Mrs Joe giving way to the very different double-act of Joe and Biddy – and then again to the very different (or should that be oddly similar?) symbiosis of Jaggers and Wemmick. There is, I hope, something peculiarly unsettling (and, for this story of nemesis, peculiarly right) about the suggestion that the features of the eminently lovable Herbert should suddenly transform into those of the implacably hostile Compeyson.

The doubling does assume that actors can switch roles in seconds, and in full sight of the audience. This does mean that the costume design, no less than that of the set, will have to capitalise on Dickens' great ability to make a characteristic evoke a character; Mrs Joe, for instance, is her apron, and Joe-in-London is a clutched hat – just as much as Miss Havisham is a piece of rotted silk, coming much too close to a flame...

This script was commissioned by the Aberystwyth Arts Centre, for a production directed by Alan Lyddiard which opened there in March 2007. I am glad to dedicate it to the company of actors which created that first production.

<div align="right">

Neil Bartlett
November 2006

</div>

The Company

1

Mr Phillip Pirrip, known in childhood as 'Pip'

2

Joe Gargery / Mr Jaggers

3

Mrs Joe / Biddy / Wemmick

4

Miss Havisham

5

Estella

6

Mr Pumblechook / Sarah Pocket / Bentley Drummle

7

Herbert Pocket / Compeyson / Mr Wopsle

8

Abel Magwitch / A Sergeant

All other roles are played by actors **2** to **8**

This dramatisation of *Great Expectations* was first performed at the Abertystwyth Arts Centre on 7 March 2007, with the following cast:

PIP, Daniel Rigby

JOE GARGERY / MR JAGGERS, Jim Kitson

MRS JOE / BIDDY / WEMMICK, Karen Traynor

MISS HAVISHAM, Angela Clerkin

ESTELLA, Zannah Hodson

MR PUMBLECHOOK / SARAH POCKET / BENTLEY DRUMMLE,
 David Ress Talbot

HERBERT POCKET / COMPEYSON / MR WOPSLE,
 Simon Tcherniak

MAGWITCH / A SERGEANT, Daniel Copeland

Director Alan Lyddiard

Set and Costume Designer Simon Banham

Original Music Jim Kitson

Lighting Grant Barden

Sound Andy Gatherar

AV Claire Duthie

Stage Manager Stu-Art James

PROLOGUE

A man, remembering.

Sounds echo in his memory: a fire, a woman screaming, and the sound of a paddle steamer, getting inexorably louder and louder. As the crescendo becomes intolerable, he puts his hands over his face. With that gesture, suddenly, all the sound stops.

He takes his hands away from his face; looking at them, he remembers how they came to be so badly scarred.

He looks at the audience, and decides to tell his story.

SCENE 1

PIP, aged 34, is alone. There are seven closed doors; in this first scene, they are the seven gravestones.

PIP: I never saw my father or my mother.

And never any likeness of them neither – their days were long before the days of photographs. My first fancies of what they were like were derived – unreasonably, I know – from their tombstones. The shape of the letters on my father's gave me the idea that he must have been a square, stout man, with curly black hair. From the inscription on my mother's – *Also Georgiana, Wife of the Above* – I decided she must have been freckled, and sickly. As for the five little ones, arranged in a neat row, *Children of the Aforesaid*, I thought – (*His solitude strikes him hard; a beat.*) – well the stones were so little, and lozenge-shaped, I thought they must all have been born on their backs, with their hands in their pockets, and having given up trying to get a living exceedingly early in that universal struggle, never taken them out.

My father's family name being Pirrip, and my Christian name Phillip, my infant tongue could make of both names nothing longer than Pip. So, I called myself Pip, and Pip I became. I give Pirrip as our family name on the authority of his tombstone, and of my sister –

MRS JOE: (*A vision of bonneted fury, suddenly sweeping out of one door and into another, announcing.*) His sister, Mrs Joe Gargery, who married a *blacksmith.*

PIP is stopped in his recollections for a moment.

PIP: I remember –

I remember knowing, that afternoon, that that bleak place, overgrown with nettles, was a churchyard, out on the marsh country by the river. That Phillip Pirrip, *Late of this Parish*, and *Also Georgiana, Wife of the Above*, were dead, and buried, and gone; and my five little brothers dead and buried too – and that the wind was blowing off the sea, and that I –

that I was seven, and afraid of it all, and beginning to cry –

Without warning, a door has opened – and MAGWITCH has a knife at his throat.

MAGWITCH: Hold your noise.

Terrified, PIP does as he is told. Other doors slowly open, just a crack; the rest of the COMPANY spy on his ordeal.

Keep still.

Keep still – or I'll cut your throat.

PIP: (*In the voice of a seven year-old.*) O! Don't cut my throat sir! Pray don't do it, sir.

(*Then, in his adult voice, and to the audience.*) I was terrified.

MAGWITCH: Tell us your name. Quick.

Tell us your name!!!!

PIP: Pip, sir. My father's name being Pirrip, and mine Phillip, I –

MAGWITCH: What?

PIP: Pip. Pip, sir.

MAGWITCH stares at him.

MAGWITCH: Where's your mother?

PIP: (*Pointing at a tombstone.*) There sir! (*MAGWITCH goes to bolt; then stops.*) There. *Also Georgiana.* That's my mother.

MAGWITCH: Oh. And your father?

PIP: Yes sir, him too: *Late of this Parish,* there sir.

MAGWITCH: Who d'ye live with then – supposing you're let to live.

PIP: My sister.

MRS JOE: Mrs Joe Gargery, who married Joe Gargery, the *blacksmith.*

MAGWITCH: Blacksmith, eh?

PIP: There was a great iron, on his leg…

MAGWITCH: Now lookee here. You know what a file is?

PIP: Yes sir.

MAGWITCH: And you know what 'wittles' is?

PIP: Yes sir food sir.

The COMPANY join in as MAGWITCH deliberately terrifies PIP.

MAGWITCH: You get me a file; and you get me wittles; and you bring 'em both to me. Or I'll have your heart and liver out –

COMPANY: Out! –

PIP: Yes sir –

MAGWITCH: Tomorrow morning, early, you do it; and you never dare to say a word or I'll have 'em out, and roasted, and ate. There's a young man, hid with me on these marshes, in comparison with which I am a Angel, and which young man has a secret peculiar way of getting at a boy, and at his heart, and at his liver; a boy may lock his door,

COMPANY: Lock it!

MAGWITCH: He may be warm in bed, but this young man will softly creep

COMPANY: Creep…

MAGWITCH: and creep and Tear… Him… Open!

The COMPANY emit sounds of violent evisceration.

I am keeping that young man off from harming you at the present, but with great difficulty; I'm finding it wery hard to hold that young man from off of your insides. Now, what do you say?

PIP: I said I would.

MAGWITCH: Lord strike you dead if you don't.

ONE OF THE COMPANY: Say yes…

PIP: Yes sir. Dead sir.

COMPANY: Dead!

MAGWITCH: Now get off home. And remember –

PIP: (*As his adult self; to MAGWITCH.*) I do remember you, I do – I remember everything… (*To the audience, as the doors slowly close, and MAGWITCH disappears.*) I remember him clasping himself, as if to hold himself together – and him turning round, to look at me… (*In memory, he feels again the cold of the marshes.*) I remember running all the way home without stopping…and the marshes…all black…

JOE GARGERY is there behind him;

JOE: Pip?

PIP: Joe!

A moment of recognition across the years:

Oh, Joe –

But JOE stops him from wasting any valuable time in reminiscence, as the COMPANY, who seem to be frightened of something, rush to assemble the Gargery kitchen for the next scene – JOE explains:

SCENE 2

JOE: Mrs Joe's been out a dozen times, looking for you, Pip. And what's worse, she's got Tickler with her.

The COMPANY get out of the way – quick.

PIP: Has she Joe?

JOE: She's on the Ram-Page, Pip old chap, the Ram-Page. Best get that towel betwixt you.

PIP hurries to get a towel down the back of his trousers, but too late; enter MRS JOE, on the Ram-Page, with the Tickler. JOE does his best to protect him, but to no avail.

MRS JOE: Where have you been, you young monkey? Tell me directly, or I'll have you out of that corner if you was fifty Pips.

PIP: Only to the churchyard.

MRS JOE: Churchyard! If it warn't for me you'd have been to the churchyard long ago, and stayed there. (*She grabs him and beats him.*) Who brought you up by hand?

PIP: You did.

MRS JOE: And why did I do it, I should like to know?

PIP: I don't know.

MRS JOE: I'd never do it again, I know that. I've never had this apron of mine off since born you were. It's bad enough to be a blacksmith's wife, and him being a Gargery, without being your mother. Churchyard, indeed! You'll drive *me* to the churchyard one of these days, and oh, a pr-r-recious pair you'd be without me. Now wash your hands – and Gargery – set the tea.

Frightened hands through doors offer the tea things, and the table gets laid. Just at the critical point, as the teapot is poised for MRS JOE to pour – the distant boom of a gun is heard out on the marshes.

JOE: Ah! There's another conwict off.

PIP: What does that mean, Joe?

MRS JOE: Escaped.

JOE: There was a conwict off last night, after sunset. They fires, Pip, as a warning.

A second gun.

JOE: Two of them.

PIP: Who's firing?

MRS JOE: Drat the boy; ask no questions, and you'll be told no lies.

Silently, JOE warns PIP to be quiet – but he can't resist…

PIP: Mrs Joe, I should like to know – if you shouldn't much mind – where the firing comes from.

MRS JOE: Lord bless the boy! From the Hulks.

PIP: Oh-h. What's Hulks?

MRS JOE: (*To audience, aggrievedly.*) That's the way with this boy, you see; answer him one question, and he'll ask you a dozen directly. (*To PIP.*) Hulks are prison-ships. Cross th'meshes.

PIP: Who's put in them, I wonder, and why.

MRS JOE: I'll tell you what, young fellow, I didn't bring you up by hand to badger people's lives out. Because they murder, and because they rob, and because they lie. All sorts of bad. And they always begin by asking questions. Now: bed! (*She hits him.*)

PIP: Ow!

On this gesture, JOE and MRS JOE suspend.

I went upstairs in the dark like I was told…and I was terrified.

Terrified of the young man who wanted my heart and liver;

Terrified of the man with the iron on his leg;

Terrified, because I had begun by asking questions, and now – now, I was going to be a thief… (*Whispering so MRS JOE won't*

hear him.) I got up (*He does.*) and went down stairs. (*He does.*)
Every crack in every board called out:

COMPANY: Stop, Thief!

PIP: and:

COMPANY: Wake up, Mrs Joe!

PIP: From the pantry (*Doors creak open, and the relevant props are handed to him.*) I stole some bread, a rind of cheese, some brandy in a stone bottle, and...a beautiful, round, compact pork pie. From Joe's tools, (*Someone gets it out of JOE's pocket.*) I stole a file. Then, I unlocked and unbolted the front door... (*He checks that JOE and MRS JOE are still frozen.*)

And I ran for the marshes.

SCENE 3

PIP: It was a misty morning; marsh-mist.

Damp –

Clammy –

Chilly –

Muddy –

COMPANY: *Guilty!!* There goes a boy with somebody else's pie!

PIP: I couldn't help it! It wasn't for myself I took it –

COMPANY: *Liar!*

PIP: It was as cold as iron; I can remember, however fast I went, I couldn't warm my feet, what with the mist and the mud and all those ditches – (*He stops; panting, out of breath.*)

Then –

Through the mist – or through a door – we see a man dressed just as MAGWITCH was dressed, but with his back turned.

There he was. I thought he would be glad to see me, with his breakfast; so I went forward softly, and touched him on the shoulder –

Before he can even do it, the man spins round. It is COMPEYSON.

(*Terrified.*) Ah! It wasn't him – he was the same – no hat, broken shoes, iron on his leg – but he didn't have the same face –

COMPEYSON: Damn you… (*He lurches forward to grab* PIP, *then lets out a yelp of pain as the metal bites at his ankle.*) Damn you, boy…

He limps horribly away.

PIP: …not the same face at all. He was badly bruised, with a great scar, just…here. (*He closes his eyes and fights to make the memory of* COMPEYSON *go away. When he opens them again,* MAGWITCH *is there.*)

MAGWITCH: You brought no one with you?

PIP: No, sir! No!

MAGWITCH: No one follow you?

PIP: No!

MAGWITCH: (*He grabs him and ransacks him for the food.*) What's in that bottle?

PIP: Brandy.

MAGWITCH stops mid-drink, because he thinks he hears something; decides it's nothing, and carries on. He finishes the brandy, and moves on to the pie.

He eat like our dog

I'm glad you enjoy it.

I said I was glad you enjoyed it.

MAGWITCH: Thankee my boy. I do.

PIP: I'm afraid you won't leave any of it for him.

MAGWITCH: Him? Who's him?

PIP: The young man. That's hid with you.

MAGWITCH: Oh, him. (*Still eating.*) He don't want no wittles.

PIP: He looked as though he did.

MAGWITCH: (*Stopping.*) Looked? When?

PIP: Just now.

MAGWITCH: Where?

PIP: Over there – I thought it was you. You know, with the – with the same reason for wanting to borrow a file. And he had a scar.

MAGWITCH: Not here?

PIP: Yes sir.

MAGWITCH: (*Stowing any uneaten food.*) Show me the way he went – I'll pull him down like a bloodhound. (*The iron bites his badly-chafed leg; he cries out in pain, and curses.*) Where's that file, boy.

PIP gives it him. MAGWITCH starts filing at his iron like a madman, ignoring the pain. The sound of filing grows and echoes as this image of MAGWITCH is hidden by the mist, or a closing door. PIP tries to get back into his place from the previous scene without being caught, but –

SCENE 4

MRS JOE: And where the deuce have you been this time?

PIP: Walking.

COMPANY: Liar!

MRS JOE: Well! Perhaps if I warn't a slave with her apron never off, I should get to go walking. As it is, I've a table to lay, a dinner to dress, a blacksmith for a husband, and (*Knocking at the door.*) – Joe Gargery, get that! – company. (*By way of explanation.*) It being Christmas.

A flurry of activity; laying of table, putting on of paper hats, opening of door, brushing of snow off shoulders, JOE in a clean collar for Christmas etc.

MR WOPSLE: Mrs Joe!

PIP: Mr Wopsle – A clerk at our church.

MR WOPSLE: Amen!

MR PUMBLECHOOK: Mrs Joe –

PIP: And Uncle Pumblechook – who wasn't really my Uncle.

MR PUMBLECHOOK: Mrs Joe, I have brought you, Mum, as the compliments of the season, a bottle of sherry wine – and I have brought you, Mum, a bottle of port wine.

MRS JOE: Oh, Un-cle Pum-ble-chook! This IS kind!

PIP: He did that very year.

MR PUMBLECHOOK: It is no more, Mum, no more than your merits. And now: Mr Wopsle? –

MR WOPSLE: Ahem. For what we are about to receive, may the Lord make us truly grateful.

MR PUMBLECHOOK: (*To PIP.*) Do you hear that? Grateful!

MR WOPSLE: Especially, boy, to them that brought you up by hand.

MR PUMBLECHOOK: Ah, why is it, Mum, why is it the young is never grateful?

MRS JOE: Why is it, Uncle?

MR PUMBLECHOOK: Naterally Wicious!!

MR WOPSLE: Amen!

PUMBLECHOOK / MRS JOE / JOE: Amen.

PIP: …Amen

Cutlery is poised for the beginning of the meal, but instead of beginning to eat, everyone suddenly slumps back in their seats with a sigh of satisfaction, as if sated – we have jump-cut to the end of the meal.

MR PUMBLECHOOK: Mum, what a meal! And what this boy has to be grateful for! Enjoying himself with his elders and betters,

improving himself with their conversation, rolling in the lap of luxury –

MR WOPSLE: Amen!

MRS JOE: Do have a little brandy, Uncle – (*PIP freezes at the mention of the stolen brandy.*)

MR PUMBLECHOOK: And yet –

MRS JOE: – and you must taste, Uncle, you must taste, to finish with, some Pie.

Her guests are stopped in their tracks by gluttonous delight at this prospect; PIP, by terror.

MR PUMBLECHOOK: Pie, Mum?

MRS JOE: A savoury pork pie.

MR PUMBLECHOOK: A bit of savoury pork pie, Mum, can lay atop anything you could mention, and do no harm. Partake we will.

MRS JOE: Then I'll just go to the pantry and get it…

JOE: (*Seeing PIP frozen in terror and consternation.*) Pip old chap?

MRS JOE: (*In the pantry.*) Gracious goodness gracious me, whatever –

Eventually, re-enter MRS JOE, vexed; the rest of the COMPANY peer into the room to see what is going to happen, adding to the pressure on PIP. As he breaks for the door, running for his life –

SCENE 5

A violent banging at the front door. PIP dares not open it, but under threat of violence from MRS JOE, eventually does so.

A SERGEANT: Excuse me, ladies and gentlemen, but I and my colleagues are on the chase in the name of the King, and want a blacksmith.

MRS JOE: And what might you want with *him*?

SERGEANT: Missis, speaking for myself, I should reply, the honour and pleasure of his fine wife's acquaintance; speaking

for the King, I answer, a little job done. You see, we have had an accident with these, (*Holding up a pair of broken handcuffs.*) and they are wanted for immediate service.

MR WOPSLE: Convicts, Sargeant?

SERGEANT: Ay! Two, out on the marshes. Anybody seen anything?

EVERYONE: (*Except PIP.*) No.

No!

No good gracious –

Amen!!

SERGEANT: Well, they'll soon find themselves trapped. Now, blacksmith. When you're ready, his Majesty the King is.

JOE dons his blacksmith's apron, takes the handcuffs, and sets to work on them. The lines of the next conversation are punctuated by the blows of a hammer on an anvil.

MR PUMBLECHOOK: Give the Sergeant some brandy, Mum.

Hammer!

SERGEANT: His Majesty's Health!

Hammer!

WOPSLE / PUMBLECHOOK: Amen!

Hammer!

SERGEANT: And your's Mum. May you live a thousand years!

Hammer!

WOPSLE / PUMBLECHOOK: Amen!

The SERGEANT drains his glass to a final flurry of hammer-blows. The handcuffs are returned and tested.

SERGEANT: Right! And should you go down with us soldiers, gentlemen, and see what comes of the hunt?

MR PUMBLECHOOK: Well I…

MR WOPSLE: I should sir – if, of course, Mr Gargery…

SERGEANT: Mr Gargery, sir?

JOE: Well…if Mrs –

MRS JOE: If you bring that boy back with his head blown to bits by a musket, don't look to me to put it back together again!

As she jabs her finger at JOE, the scene once again suspends…

SERGEANT: Well then, gentlemen, to the business; *out into the air –*

…and we see and hear the marshes.

PIP: The raw, night air.

SCENE 6

SERGEANT: Fall in, men – and you, gentlemen; not a word.

They are joined by the COMPANY, and create an image of a line of men sweeping the marshes, 'steadily moving towards their business'. Night.

PIP: (*Whispering.*) I hope, Joe, I do hope we shan't find them.

JOE: I'd give a shilling if they'd cut and run, Pip.

PIP is lifted up on JOE's back.

At a command from SERGEANT, the rhythm of the hunt begins.

At a gesture from the SERGEANT, everyone stops and listen.

SERGEANT: Nothing.

Repeat; this time, a distant shouting is heard.

SHOUTING IN THE DISTANCE: He's here!!

SERGEANT: At the double…

A SUDDEN SHOUT: Here!! Murder!!

SERGEANT: Run!!

Darkness, beams of light, confusion

COMPANY: This way!
Convicts!

Runaways!
Guard!!
Here!! They're here!!

In the beams of the torches, we see a tangle of two desperate bodies:
MAGWITCH and COMPEYSON.

SOLDIER: Surrender!! Confound you for beasts, surrender!!!

They are forced apart.

Handcuffs there.

JOE supplies them.

MAGWITCH: I took him. And he knows it.

COMPEYSON: He tried to murder me…

MAGWITCH: I took him, and I giv'im up; that's what I done.
Dragged him back.

COMPEYSON: …murder me…

MAGWITCH: Let you go free? Let you make a fool of me again?
No! (*He tries to get at him again, but is prevented.*)

COMPEYSON: Ah!

MAGWITCH: He's a liar! And he'll die a liar!

SOLDIER: Enough!!! Light the other torches.

MAGWITCH sees PIP; their eyes lock.

All right, you. March.

MAGWITCH: I wish to say something.

SOLDIER: You can say what you like, but it won't –

MAGWITCH: Respecting this escape. It may prevent some persons
laying under suspicion alonger me.

SOLDIER: Go on.

MAGWITCH: I took some wittles –

SOLDIER: You mean, *stole.*

MAGWITCH: – and I'll tell you where from. From the blacksmith's
– a pie, it was.

JOE: Pip!

MAGWITCH: So you're the blacksmith, are you? Well I'm sorry to
say I've eat your pie.

JOE: God knows you're welcome to it. We don't know what you
done, but we wouldn't have you starved to death for it, would
us, Pip. Pip?

Pip?

*MAGWITCH stares at him, and the boom of a gun reverberates in
PIP's memory…*

PIP: I'd been waiting all the time for him to look at me, that I
might try to assure him, I hadn't betrayed him – but when he
did look, it…it all passed so quickly!

SOLDIER: Come on, you.

MAGWITCH is taken away.

PIP: They put him in a boat, and they rowed him away. The guard
were all ready – no one seemed surprised to see him back
in irons, or sorry to see him, or glad…somebody in the boat
growled.

ANOTHER SOLDIER: Give way, you!

PIP: – as if it was an order given to dogs –

and the oars dipped, and I watched him…

disappear…

ONE OF THE COMPANY: There was a torch, and someone flung it
hissing into the water –

PIP: And it went out, as if…

As if it was all over.

PIP and JOE are left together.

JOE: Pip old chap…what larks, eh Pip?

27

Pip?

As PIP *is lost in thought, another gun-boom reverberates in his memory.*

Then:

SCENE 7

MRS JOE: (*Exasperated by all this introspection, washcloth in hand.*) Was there ever such a boy as this? Fed, scrubbed, clothed, pompeyed – and is he grateful? Is he? No; too busy with mud and meshes and *convicts* – (*She suddenly stops scrubbing at him – and out of nowhere, in a different voice, asks him.*)Well were you? Ever? Grateful? Were you? Oh!

Across the years, PIP *looks at her. She slaps him hard around the face and exits.*

JOE: Don't cry old chap... I don't deny, Pip, that your sister, Pip, your sister do drop down upon us heavy sometimes –

PIP: (*In his adult voice, still staring after her.*) Why –

JOE: – but you see, Pip, what with the drudging and slaving and never getting no peace in all her mortal days...well Pip, just remember; Whatsume'er the failings on her part, remember she were that good in her heart. Eh Pip?

PIP: I remember. Don't mind me, Joe.

Satisfied that PIP *is alright,* JOE *gets back into his apron and again punctuates the next brief passage with blows to his anvil.*

When I was old enough, I was to be apprenticed to Joe, and until then I frightened birds (*Hammer!*) and picked up stones – (*Hammer!*) odd-boyed about the forge – (*Hammer!*) whatever happened to be wanted. Then, one night – (*Hammer! Hammer! Hammer!*)

MRS JOE: Well!!

MR PUMBLECHOOK: Well if that boy ain't grateful this night, he never will be!

MRS JOE: It's only to be hoped, Uncle Pumblechook, it's only to be hoped he won't be *pompeyed*. But I have my fears!

MR PUMBLECHOOK: She ain't in that line, Mum. *She* knows better.

MRS JOE: (*To JOE.*) Well? And what are you staring at? Is the house a-fire?

JOE: She?

MRS JOE: Miss Havisham. Miss Havisham is a she, I suppose?

JOE: Miss Havisham *up town*?

PIP: Everybody had heard of Miss Havisham up town –

MR PUMBLECHOOK: *Immensely* rich –

MRS JOE: *She* wants this boy to go and play there. And he'd better play, or I'll work him.

JOE: I wonder how she come to know our Pip?

MRS JOE: Isn't it just *barely* possible that Uncle Pumblechook might be a tenant of hers, and that he might sometimes – *sometimes* – go there to pay his rent – and couldn't she then ask if he knew of a boy, to play, and couldn't Uncle Pumblechook, then, being always considerate and thoughtful for us – *Joseph* – then perhaps *mention* this boy, that I have for ever been slave to?

MR PUMBLECHOOK: Prettily pointed, Mum.

MRS JOE: And, (*Grabbing PIP, and letting out a piercing whistle or shout to summon the rest of the COMPANY, who dash on with clean clothes, haircombs, towels and whatever else is required for the scrubbing, combing and trussing of PIP ready for his journey to Satis House.*) for anything we can tell, *Joseph*, though *you* may not think it, this boy's fortune may be made by his going to Miss Havisham's –

MR PUMBLECHOOK: *Immensely* rich.

MRS JOE: – which is why Uncle Pumblechook, being sensible to that case, has offered to take him into town, tonight, and, *in his own chaise cart.*

PIP is transformed; MRS JOE hands him over.

MR PUMBLECHOOK: Mum!

MR PUMBLECHOOK invites PIP to take his place in the cart. Just before he hands him up in to it:

Boy, be for ever grateful to all friends; but especially unto them which brought you up by hand.

SCENE 8

The Journey to Satis House. 'It was a cold, dry night, with no pity in the glittering multitude of stars...the sound of the mare's iron shoes upon the hard road...'

MR PUMBLECHOOK: Well boy, I dare say that what with your feelings –

PIP: Yes sir.

MR PUMBLECHOOK: And that new collar –

PIP: Yes sir.

MR PUMBLECHOOK: You can hardly see no stars.

PIP: No sir.

MR PUMBLECHOOK: But even if you could –

PIP: Sir?

MR PUMBLECHOOK: They would hardly throw any light on the question why on earth you are sent for to play at Miss Havisham's –

PIP: No, sir.

MR PUMBLECHOOK: Or what on earth you are expected to play at once we get there...

PIP: No sir.

Beat.

MR PUMBLECHOOK: Seven times seven.

PIP: Sir?

MR PUMBLECHOOK: Seven times seven.

PIP: Forty-nine, sir.

MR PUMBLECHOOK: Hmmph!

We see the looming front door of Satis House. PIP, confronted with this memory, stops. PUMBLECHOOK, exasperated by the boy, rings the doorbell. Nothing. He rings it a second time.

SCENE 9

THE VOICE OF A SEVEN YEAR-OLD GIRL: What name?

MR PUMBLECHOOK: Pumblechook.

THE VOICE: Quite right.

The door is unlocked and opened.

MR PUMBLECHOOK: This, is Pip.

ESTELLA: Come in, Pip. (*To PUMBLECHOOK.*) Did you wish to see Miss Havisham?

MR PUMBLECHOOK: If Miss Havisham wished to see me.

ESTELLA: Ah! But you see she doesn't.

She closes the door in his face, and locks it. She stares at PIP.

Inside Satis House: ESTELLA, carrying a candle, leads him through the labyrinthine darkness of the house, unlocking doors and locking them behind her.

PIP: What is the name of this house, miss?

ESTELLA: Satis. Which is Greek, and Latin, and Hebrew, for 'Enough'.

PIP: That's a curious name, miss.

ESTELLA: Yes. It means more than it says. It meant, when it was given, that whoever had this house could want for nothing

else. They must have been easily satisfied in those days I suppose. Don't loiter, boy.

They arrive at the final door.

PIP: After you, miss.

ESTELLA: Don't be ridiculous, boy. *I'm* not going in.

She knocks on the door.

A VOICE BEHIND THE DOOR: Enter.

SCENE 10

Like an apparition lit by candle-flames, MISS HAVISHAM, in the wreckage of her bridal chamber.

MISS HAVISHAM: Come nearer; let me look at you. You are not afraid of a woman who has never seen the sun since you were born?

PIP: No.

MISS HAVISHAM: Do you know what I touch, here?

PIP: Yes, ma'am. Your heart.

MISS HAVISHAM: Broken!

I am tired, and I want diversion. I have sick fancies sometimes, and I have a sick fancy that I want to see some play. Play, boy, play!

Are you obstinate?

PIP: I am very sorry ma'am, I can't play just now. I would if I could, but it is so new here, and so strange –

MISS HAVISHAM: So new to him, so old to me. Estella!

ESTELLA comes when she is called.

Let me see you play cards with this boy.

ESTELLA: But he is a common labouring-boy!

MISS HAVISHAM: Well? You can break his heart.

ESTELLA: What do you play, boy?

PIP: Nothing but 'beggar my neighbour', miss.

MISS HAVISHAM: Beggar him.

As ESTELLA lays out the cards…

PIP: (*In a whisper.*) I realised that everything in the room had stopped: her watch; the clocks; her life –

ESTELLA: What coarse hands he has. And what thick boots!

PIP: She was right, of course. They were.

ESTELLA: (*As PIP makes a mistake.*) What a stupid clumsy boy you are. A labouring boy.

MISS HAVISHAM: You say nothing of her. She says many hard things of you, but you say nothing of her. What do you think of her?

PIP: I think she is very proud.

MISS HAVISHAM: Anything else?

PIP: I think she is very pretty.

MISS HAVISHAM: Anything else?

PIP: I think she is very insulting.

MISS HAVISHAM: Anything else?

PIP: I think I should like to go home.

MISS HAVISHAM: And never see her again, Pip?

PIP: I am not sure that I shouldn't like to see her again, but I should like to go home.

MISS HAVISHAM: You shall. Come again after six days.

PIP: I could have said no. But I said… Yes.

Yes Miss Havisham… I'll come Wednesday, ma'am –

MISS HAVISHAM: I know nothing of days of the week; nothing, of the weeks of the year. Estella, take him down. Goodbye, Pip.

They journey back through the dark house. As they do:

COMPANY: *Coarse…*

Coarse hands.
And what thick boots.
Would you like to go home?

ESTELLA leaves him stranded:

ESTELLA: Wait here.

COMPANY: You vulgar
Ignorant
Low-living
Boy...
Boy! Boy! Boy!

The voices push him too far; PIP, humiliated, cries and kicks at a door. ESTELLA returns, and he conceals his feelings.

ESTELLA: Why don't you cry?

PIP: Because I don't want to.

ESTELLA: You do. You've been crying till you are half blind. Goodbye.

Laughing, she pushes him out and locks the door.

PIP: (*Working hard to suppress his emotions as he justifies himself.*) I suppose my upbringing had made me sensitive. I suppose that in that little world – that violent, capricious world – I had always known – through all my punishments and disgraces – always nursed, in my solitary and unprotected way, the profound conviction that –

But MRS JOE has no time for all this soliloquising and introspection, so –

SCENE 11

MRS JOE: Yes yes yes... Well?

MR PUMBLECHOOK: How did you get on, *up town*?

PIP: I was sure they wouldn't understand, so I lied. Pretty well.

MR PUMBLECHOOK: Pretty well! Pretty well is no answer.

MRS JOE: (*Losing her rag and about to hit.*) Ah!

MR PUMBLECHOOK: (*Stopping her.*) Mum; leave this lad to me. Boy! what like is Miss Havisham?

During the next conversation, MRS JOE and MR PUMBLECHOOK behave as if they are being told all the marvellous and outlandish details of life in Satis House: what we hear, from PIP, are the thoughts that he is concealing under a wildly embellished account of his visit.

PIP: Like a corpse. Every clock in the room is stopped at twenty minutes to nine.

MR PUMBLECHOOK: (*Impressed.*) Is she! And what was she a-doing of, when you went in?

PIP: And there was a beautiful young lady there, who was dreadfully proud.

MRS JOE: No daylight???

MR PUMBLECHOOK: And what did you play, boy?

PIP: She said I was common, and now I know I am.

MRS JOE / PUMBLECHOOK: (*Amazed and delighted.*) Ah!

PIP: And I wish with all my heart that I was not.

MR PUMBLECHOOK: There is no doubt, mum, no doubt that Miss Havisham will do something for this boy.

MRS JOE: Property, Uncle Pumblechook; *property.*

JOE: Well Pip; what larks…

As they gaze into the boy's glorious future…

PIP: Yes; a memorable day. Imagine, Ladies and gentlemen, in your life, if one selected day could be struck out of it – think how different its course would then have been… Pause, and think – for just a moment…of the chains of iron, or of gold, or of flowers, that would never have bound you, but for the formation of that first link, on that first, memorable day.

JOE has been watching him, concerned that he's getting himself into a state again.

JOE: Pip old chap…

PIP: Yes Joe?

JOE: Upstairs to bed, Pip, I should say.

PIP: Yes Joe.

JOE: And when is you to go back Pip?

PIP: Next Wednesday, Joe; next Wednesday.

I spent the whole of that night thinking how common Estella and Miss Havisham would think Joe. And of what a coarse and common thing I was; and, what was worse, on secret terms of conspiracy with convicts. (*In the night, the sound of MAGWITCH's file.*) I tried to think about Miss Havisham's, about next Wednesday; but in my sleep all I saw was a door…and a file – that file, coming at me out of the door, and I couldn't see who was holding it, and I –

At the very moment, in his nightmare, that he starts awake – we hear the echoing doorbell of Satis House, and see not MAGWITCH with the file coming through the door, but ESTELLA with her candle.

SCENE 12

ESTELLA: You are to come a different way today.

She leaves him stranded in an empty corridor.

You are to wait in here, until you are wanted.

Suddenly, all the POCKETS tumble out of a door. They inspect him.

SARAH: The idea!

MR CAMILLA: No, no; IT WILL NOT DO. For the sake of the family.

SARAH: The family!

CAMILLA: *Very* true!

SARAH: The idea!

ESTELLA: (*Returning.*) Boy! She wants you.

SARAH: Well, I am sure!

CAMILLA: Was there ever such a fancy?

SARAH: The i-*de*-a!

They vanish.

In a dark corridor, ESTELLA suddenly stops.

ESTELLA: Well? Am I still pretty?

PIP: I think you are very pretty.

ESTELLA: Am I insulting?

PIP: Not so much as you were last time.

She slaps him, hard, on the face.

ESTELLA: You coarse little monster, what do you think of me now?

PIP: I shan't tell you.

ESTELLA: Why don't you cry again, you little wretch?

PIP: I'll never cry for you again!

A door has opened behind them. An unidentified, shadowy figure appears, wiping his hands on a handkerchief.

THE FIGURE: Whom have we here, Estella?

ESTELLA: A boy.

THE FIGURE: How does he come here?

ESTELLA: Miss Havisham sent for him.

THE FIGURE: Did she? Did she indeed?

He looks at his watch, unlocks a door (with his own key), and disappears into the house.

PIP: That must have been the first time I ever saw him –

ESTELLA: This way, boy!

She ushers him into another candle- and fire-lit room; we see MISS HAVISHAM, amidst the ruins of her bridal feast.

MISS HAVISHAM: So! The days have worn away, have they?

PIP: Yes, ma'am, today is –

MISS HAVISHAM: I don't want to know!

This, is where I will be laid when I am dead. They shall all come and look at me… What do you think that is?

PIP: I don't know.

MISS HAVISHAM: It's a great cake. A bride-cake. Mine! It and I have worn away together… The mice have gnawed at it, and sharper teeth than teeth of mice have gnawed at me. Walk me, walk me…

This is my birthday, Pip.

He is going to wish her happy birthday, but she lifts her stick and stops him –

I won't suffer it to be spoken of. Not by anyone!

Suddenly, the room is full of POCKETS, in maximum cringing and begging mode, followed by ESTELLA.

CAMILLA: Oh, but –

MR CAMILLA: Oh!

SARAH: But *Dear* Miss Havisham: how well you look.

MISS HAVISHAM: I do not.

SARAH: No –

CAMILLA: No –

MR CAMILLA: No, she doesn't –

SARAH: The idea!

MISS HAVISHAM: And how are *you*?

CAMILLA: Oh, as well as can be expected – not expecting any thanks, or anything of that sort, for coming here, no, certainly not…

MISS HAVISHAM: Expecting? (*She turns on them.*) …When I am laid out on this table, that will be your place, and that yours, and that yours. When you come to feast upon me. Now go! Go!

SARAH: The idea! Bless you! Bless you!

They have gone. MISS HAVISHAM stands and stares as if she could see her dead self laid on the table.

On this day of the year, long before you were born, Pip, this heap of decay was brought here. When the ruin is complete, and the curse is finished, and they lay me, dead, in my bride's dress on the bride's table – so much the better if it is done on this day.

She takes a jewel from her throat and gives it to ESTELLA.

Your own, my dear, then. Use it well.

(*Fitting the jewel, and whispering in her ear.*) Break their hearts my pride and hope; break their hearts and have no mercy.

As she wishes him to be, PIP is transfixed.

Show the boy out, Estella.

She does, then locks door behind her; and then says, evidently with a plan:

ESTELLA: Wait here.

SCENE 13

ESTELLA doesn't come back. PIP tries several different doors, but they are all locked. Then, behind him, one opens.

A PALE YOUNG GENTLEMAN: Hulloa.

PIP: Hulloa.

THE GENTLEMAN: Who let *you* in?

PIP: Miss Estella.

THE GENTLEMAN: Did she give you leave to prowl about?

PIP: Yes.

THE GENTLEMAN: I see. (*He puts his fists up. PIP doesn't respond.*) Fight! Come on, let's fight.

> *The PALE YOUNG GENTLEMAN starts dancing around like a boxer. PIP is nonplussed.*

I suppose I ought to give you a reason. (*He slaps PIP.*) There.

> *They fight, and PIP takes out all his pent-up feelings on him. Just before he lands his final punch (and cuts his knuckles in the process), he pauses to tell the audience –*

PIP: I am sorry to record that the more I hit him, the harder I hit him.

> *PIP lands his punch. The YOUNG GENTLEMAN now has a bloody nose.*

THE GENTLEMAN: I think this rather means you have won.

PIP: Can I help you?

THE GENTLEMAN: No thankee.

PIP: Good afternoon, then.

THE GENTLEMAN: Same to you.

> *He exits. ESTELLA has been watching: there is a bright flush upon her face, as though something has happened to delight her.*

ESTELLA: Come here, boy. You may kiss me now, if you like.

> *He does.*

Now go.

> *She pushes him out and runs away, laughing.*

PIP: (*Rubbing his wounded knuckles.*) I never told anyone about that …about the pale young gentleman whose nose I broke, I mean – I suppose I might have told Joe…but anyway, I never saw him again. Estella, of course, was always there, to let me

in and out... Sometimes, she would tolerate me; sometimes, tell me energetically that she hated me. And, of course, she –

COMPANY: She grew prettier and prettier.

PIP: Yes, she did.

COMPANY: Did she ever tell you might kiss her again?

PIP: No.

COMPANY: Really? And did you cry?

PIP: Never! I never wanted to cry!

MR PUMBLECHOOK: But, but with respections to Miss Havisham, on what intentions may we speculate?

MR WOPSLE: What might she *do* with you, boy?

MR PUMBLECHOOK: Do *for* him...

MRS JOE: Do *to* him.

Suddenly; the doorbell: ESTELLA wheels in MISS HAVISHAM.

SCENE 14

MISS HAVISHAM: You are growing tall, Pip! Tell me the name again of that blacksmith of yours?

PIP: Joe Gargery, Miss Havisham.

MISS HAVISHAM: (*Scrutinising him.*) You had better be apprenticed to him at once. Let him come here, with the indentures to sign.

JOE: Me, Pip?

PIP: At any particular time, Miss Havisham?

MISS HAVISHAM: Time? I know nothing about time. Let him come soon – and come alone, with you.

JOE is rooted to the spot with terror. MRS JOE takes charge of the situation –

MRS JOE: – you great dunderheaded king of the noodles – a doormat, a doormat under your feet I am – standing there – Now!!

– sprucing him up to her satisfaction, and then pushing him into MISS HAVISHAM's presence. In this scene, JOE, overawed, communicates entirely in nods and shakes.

MISS HAVISHAM: So, Mr Gargery, does the boy like his trade?

A nod.

And have you brought the indentures with you?

Another; the indentures are handed over and signed.

You expect no premium with the boy?

A shake.

Well, Pip has earned one: here.

She produces a bag of money.

Give it to your master, Pip. Goodbye, Pip. Estella…

ESTELLA begins to wheel her away.

PIP: Miss Havisham! Am I not to come again, Miss Havisham?

MISS HAVISHAM: No. Gargery is your master now. And Gargery –

JOE nods and shakes furiously.

The boy has been a good boy here, and that is his reward. As an honest man, you will expect no other. *Expect*, no more.

ESTELLA wheels her away.

MRS JOE: Well?

JOE: As-TON-ishing! Miss 'Avisham –

MRS JOE: What did she give him?!

MR PUMBLECHOOK: How *much*…

JOE: What would present company say to ten pound?

MR WOPSLE: They'd say Amen –

MRS JOE: They'd say, pretty well. Not too much, but pretty well.

JOE: It's more than that.

MR PUMBLECHOOK: You don't mean to say –

MRS JOE: Go on, Joseph.

JOE: What would present company say, to twenty pound?

MRS JOE: Handsome. Handsome would be the word.

JOE: It's more than twenty pound. It's twenty-five.

MR WOPSLE: A-*men*!

MR PUMBLECHOOK: (*Almost apoplectic with jealousy, shaking her hand.*) Five and twenty pound, Mum! No more than your merits; no more than your merits.

MRS JOE: Goodness knows, Uncle Pumblechook, after the trouble I've had – with this boy…

The focus goes back onto the forgotten PIP, who is still staring at the space where ESTELLA was.

JOE: Pip old chap?

MR PUMBLECHOOK: And now you are apprenticed, Pip, shall you *like* being a blacksmith?

PIP: (*To himself.*) Never.

(*To the audience.*) I should have liked it, once, but once was not now. Now – I was ashamed.

MRS JOE: Oh and whose fault was that, eh? (*Indicating where MISS HAVISHAM has gone.*) Hers? Oh – Mine, I suppose…oh to hear the things he's telling you…the black ingratitude of it…my fault, was it? Was it?

She sweeps off in indignation.

PUMBLECHOOK / WOPSLE: *Naterally Wicious!!!*

They sweep off after her. A beat.

PIP: (*Angrily.*) Whose fault it was is of no moment now. The change was made; the thing was done. Excusably or inexcusably, it was done!

He looks at JOE.

I never told you how I felt. All those nights we worked at the forge together...never. No. (*With self-hatred.*) No, what I said was: (*Putting on his forge apron, and lying, brightly.*)

SCENE 15

PIP: Joe, don't you think I ought to make Miss Havisham a visit?

JOE, to displace his knowing that this is all wrong, sets to work with his hammer.

JOE: Well, Pip, what for? She might think you wanted something...

PIP: Might she?

JOE: She might old chap. You see, Pip, Miss Havisham done the handsome thing by you, but when she done that, she called me back to say most partick'ler as that were all.

PIP: Yes, Joe, I heard her.

JOE: ALL.

PIP: Yes, Joe, I –

JOE: Which I meantersay Pip, it might be that her meaning were (*Hammer!*) make an end on it Pip (*Hammer!*) as you was, Pip. (*Hammer!*)

PIP: But Joe –

JOE: Yes old chap...

PIP: I merely thought I might go up town and make a call on Miss Est – Havisham.

JOE stops whatever he is doing.

JOE: Which her name ain't Estavisham, Pip, unless she have been re-chris'ened.

PIP: I know, Joe, I know. That was a slip. What do you think of it, Joe?

JOE: Well I thinks…if you thinks well of it, Pip, then…then I thinks well of it, Pip. Old chap.

PIP takes his apron off and tidies himself up – he worries about his black hands.

PIP: And so…I went. Absurdly, and promising Joe it would be the very last time, I went back.

The doorbell of Satis House…

SCENE 16

SARAH: What do *you* want?

PIP: Only to see how Miss –

SARAH: Well you'd better come up then.

This time, SARAH is his guide through the dark house.

MISS HAVISHAM, alone by firelight.

MISS HAVISHAM: Well?

PIP: Miss Havisham, I wanted you to know that I am doing very well, and that –

MISS HAVISHAM: Ah! You are looking for Estella.

PIP: I… I hope she is well.

MISS HAVISHAM: Abroad. Educating for a lady. Admired by all who see her. Do you feel that you have lost her?

She laughs.

PIP: I feel…

MISS HAVISHAM: Yes?

PIP: I felt…felt that I – What was it?

MISS HAVISHAM: Here Pip, take a guinea. For your birthday. (*Angrily.*) Take it!!

After considering refusal, he does.

Were you expecting more, Pip? Were you? Were you expecting more?

MISS HAVISHAM laughs; SARAH wheels her away.

PIP: Miss Havisham! –

She's gone. Suddenly, the boom of a gun on the marshes; and all the COMPANY are staring at him.

PIP: What? What is it?

COMPANY: There's something wrong, Pip –

Up at your place.

PIP: I don't understand –

JOE: While you was up town, Pip…

COMPANY: Your sister.

PIP: My sister – ?

COMPANY: (*All, quietly.*) Dead.

The actor playing MRS JOE takes off and folds up her apron, as she tells us:

MRS JOE: They found her stretched out on the bare kitchen boards, just where she had fallen. She lay very ill in her bed for weeks, and eventually, at twenty past six on a Monday evening she said, quite plainly, 'Joe', and then, once, 'pardon', and once, 'Pip'; and then laid down her head, and was gone.

COMPANY: (*All, quietly.*) Gone.

MRS JOE: It was the first time that a grave had opened in his road of life, and the gap it made in the ground was wonderful. He had the strangest ideas that he could see her coming towards him in the street, or that she would presently knock at some door; now that she was gone, he found himself always wondering in what part of the house she was.

A month later, a young girl named Biddy –

MR WOPSLE: Who was Mr Wopsle's great-aunt's granddaughter – I thank you.

MRS JOE: – came to the house.

She is handed BIDDY's apron: as she puts it on, she assumes the character and voice of BIDDY.

BIDDY: She was an orphan –

PIP: Like I was –

BIDDY: – but a bright, neat, clean one, and she had come to take care of Mr Gargery.

And you, Pip. And you.

She busies herself tidying the place up – including getting the rest of the COMPANY off the stage.

PIP: (*Who is now fourteen.*) Biddy, do *you* think me coarse and common?

BIDDY: Who said that?

PIP: The beautiful young lady at Miss Havisham's.

BIDDY: Well, that was neither a very true nor very polite thing to say.

PIP: I do admire her dreadfully.

BIDDY: Do you Pip?

PIP: (*Finally coming out with what he wants to say.*) Biddy, when I grow up, I want to be a gentleman.

BIDDY: Oh.

PIP: You see I am not at all happy as I am, and I never shall be or can be, unless – unless I can lead a very different sort of life from the life I lead now. I want to be a gentleman, on her account.

BIDDY: (*Stopping her work, and gently.*) To spite her, or to gain her, Pip?

PIP: I... I don't know.

(*In his adult voice, and to the audience.*) I didn't know!! I knew, of course, that if it was to gain her, that she was not worth gaining – not like that – I knew that – but –

(*Now justifying himself to BIDDY.*) Well how could I, a poor dazed village lad, how could I possibly be expected –

This outburst is suddenly curtailed by a sudden knocking on the door.

SCENE 17

JAGGERS: (*Surveying these humble surroundings, and wiping his hands on his handkerchief.*) Well!

PIP: It was the gentleman I had seen in – !

JAGGERS: (*Cutting him off.*) From information I have received, I have reason to believe there is a blacksmith among you, by name of Joseph Gargery?

BIDDY: He's out, sir.

JAGGERS: Is he…? – Has he an apprentice, commonly known as Pip? Answer the question yes or no.

BIDDY: He has…

JAGGERS: My name is Jaggers, and I am a lawyer. In London. I commence by explaining, the unusual business I have to transact with you is not of my originating. If my advice had been asked, I should not have been here. It was not.

I, am the bearer of an offer to relieve Mr Gargery of his apprentice. (*He hands papers to BIDDY.*) And to this young fellow (*Handing over another paper to her.*) the communication I have got to make is, that he has Great Expectations.

The COMPANY have been eavesdropping, perhaps…

COMPANY: !

JAGGERS: I am instructed to communicate to him that he will come into a handsome property. Futher, that it is the desire of the present possessor of this property that he be immediately

removed from his present sphere of life, and be brought up, as a gentleman.

COMPANY: Oh!

JAGGERS: Now, Mr Pip, I address the rest of what I have to say, to you. You are to understand, first, that it is the request of the person from whom I take my instructions that you shall always bear the name of Pip – you have no objection – ?

PIP: (*He can barely stammer it out.*) None.

JAGGERS: – I should think not; second, that the name of the person who is your liberal benefactor remains a profound secret, until that person chooses to reveal it – I am empowered to mention that it is the intention of the person to reveal it at first hand, by word of mouth; when or where that intention may be carried out, I cannot say. No one can – and meanwhile, third, you are most positively prohibited from making any enquiry or any allusion or reference whatsoever as to the identity of this individual to *me*. Any objection to *that*?

PIP: N-none.

JAGGERS: I should think not! Now, Mr Pip, to details; there is, already, lodged in my hands a sum of money amply sufficient for your suitable maintenance. In addition, it is considered that you must be better educated, in accordance with your altered position. You will of course be alive to the importance and necessity of entering *at once* on that advantage.

PIP: It is what I have always longed for.

COMPANY: !!!!!!

JAGGERS: Never mind what you have always longed for, Mr Pip. If you long for it now, that's enough. First, you must have some new clothes…

The COMPANY burst in, in a flurry of obsequiousness, and swiftly give PIP all that needs to be gentleman by way of new clothes, hats, gloves, valises – whatever.

MR PUMBLECHOOK: Indeed he must sir –

COMPANY: And new gloves, sir –

　　Much in vogue among the gentry, sir –

　　A very sweet article sir –

　　Really extra super –

JAGGERS: And, you'll want some money…shall we say twenty
　　guineas?…

COMPANY: *Twenty!*

MR PUMBLECHOOK: Oh my dear friend – may I – *may* I?

MR WOPSLE: Amen!

JAGGERS: And the sooner you leave here, the better.

　　The COMPANY is stopped in its tracks by this news.

　　Leave that is, for London

COMPANY: (*Mouths, in stunned silence.*) LONDON?!

JAGGERS: (*Handing PIP a business card.*) Take a hackney carriage
　　from the coach office, and come straight to me.

PIP: Mr Jaggers –

JAGGERS: (*Already exiting.*) Hmn?

PIP: I beg your pardon, but would there be any objection to my
　　taking leave of any one I know before I go away?

JAGGERS: None.

PIP: I mean – up town.

JAGGERS: No. No objection. (*He is gone.*)

PIP: Thank you.

　　*Working hard to ignore and/or defy BIDDY's questioning stare, he
　　fiddles self-importantly with some detail of his new outfit, and then,
　　finally satisfied with his appearance – and treating the COMPANY
　　as if he were a gentleman and they were all his staff – asks them to
　　expedite the next step of his journey.*

　　Thank you!

They bring him the front door of Satis House, and there is a final flurry of obsequious, whispered farewells.

MR WOPSLE: Well deserved, sir – well deserved...

PIP rings the doorbell.

SCENE 18

At first no one comes, but then –

SARAH: (*Seeing his outfit.*) What do you want?

PIP: (*Already attempting to act the gentleman.*) I am going to London, Miss Pocket, and wished to say goodbye to Miss Havisham.

Reeling with jealousy, she slams the door in his face –

SARAH: Wait here –

A VOICE BEHIND THE DOOR: Who is it Sarah?

SARAH opens it again. Staring disbelievingly at him all the time, she escorts him in.

MISS HAVISHAM: Pip... Well?

PIP: (*Bowing.*) Miss Havisham. I thought you might kindly not mind my taking leave of you.

MISS HAVISHAM: This is a gay figure, Pip.

PIP: I have come into such good fortune, Miss Havisham, since I saw you last – and I am so grateful for it, Miss Havisham.

MISS HAVISHAM: Ah! *I* had heard about that, Pip. From Mr Jaggers. You are adopted by a rich person, are you not?

PIP: Yes, Miss Havisham.

MISS HAVISHAM: Not named?

PIP: No, Miss Havisham.

MISS HAVISHAM: And Mr Jaggers is made your guardian.

PIP: Yes, Miss Havisham.

MISS HAVISHAM: And you go tomorrow to London.

PIP: Yes, Miss Havisham.

A beat.

MISS HAVISHAM: Well!…you have a promising career before you. Be good; deserve it. Goodbye, Pip!

She stretches out her hand: PIP goes down on one knee and kisses it.

You will always keep the name of Pip, you know.

PIP: Yes, Miss Havisham.

MISS HAVISHAM: Goodbye.

MISS HAVISHAM exits.

SARAH: (*Apopleptic with jealousy.*) Deserve it? *Deserve it!!*

She exits.

PIP: Goodbye, Miss Pocket.

(*To himself.*) And goodbye… Joe.

(*To the audience.*) On the coach, I did think of turning back. But it was too late. Too far.

All the mists on the marshes had risen…and the whole world lay spread before me: like a dream!

The COMPANY peer round their doors at him again, as he takes a deep breath, and –

– the sound of MAGWITCH's file becomes visible, as the lights die leaving only PIP's expectant face…

With this image, the first half of the show ends.

INTERVAL

SCENE 19

Starts exactly where the last scene ended:

PIP takes a deep breath, conquers his fears, and announces:

PIP: London!!

At once, we hear it, and see it. PIP stares around him at the city, lost, as a series of passers-by jostle him.

The journey to the coach office took *five hours*!

A PASSER-BY: (*Snatching the business card he's looking at.*) Jaggers? Bartholomew Close. Just out of Smithfield.

PIP: Thank you – Smithfield…?

ANOTHER PASSER-BY: (*Elbows him and points out.*) Saint Paul's…

ANOTHER: (*Darkly.*) Newgate.

PIP: (*Reading his card again.*) The streets were very ugly –

ANOTHER: Very crooked –

ANOTHER: Very narrow and *dirty* –

ANOTHER: Jaggers?

ANOTHER: *Oooh! Jaggers!* (*He shakes his head as he goes.*)

PIP is left alone. A door. It has been left open.

He knocks, and cautiously enters.

SCENE 20

WEMMICK: Mr Jaggers is in court, at present – am I addressing Mr Pip – ?

PIP: You are.

WEMMICK: – but left word would you wait, Mr Pip, in his room. He couldn't say how long he might be, but it stands to reason his time being valuable he won't be longer than he can help.

PIP has been ushered into a tiny, intimidating and coffin-like room.

PIP: Thank you.

WEMMICK: Never in London before, Mr Pip?

PIP: No.

WEMMICK: I was new here once. Rum to think of it now!

PIP: Is it a very wicked place?

WEMMICK: You may get cheated, robbed and murdered, in London – but then there are plenty of people anywhere who'll do that for you, Mr Pip.

PIP: I see.

A beat.

Mr JAGGERS enters very brusquely, wiping his hands on his handkerchief, eating a sandwich in a bullying manner and drinking sherry from a flask – in all of which tasks he is symbiotically aided and abetted by WEMMICK.

JAGGERS: Ah, *you.* Well, arrangements have been made, Mr Pip, (*Hands WEMMICK a card.*) and your allowance, sir, is to be a liberal one, very liberal. You will find your credit good, Mr Pip, at the following tradesmen (*An envelope.*) – but I shall be checking all bills. You'll go wrong, of course, but that's no fault of mine. Mr Wemmick – (*And he's gone.*)

WEMMICK: Certainly Mr Jaggers.

WEMMICK passes PIP the card: he reads it.

PIP: 'Mr Herbert Pocket, Barnard's Inn.'

WEMMICK: (*Picking up PIP's valise.*) Yes sir.

Through a gate –

Down a passage –

'Cross a square –

PIP: That looked to me like a burying ground –

WEMMICK: Past the most dismal houses he had ever seen, with dilapidated doors that said To Let – To Let – To Let – and, then… – There!

They have arrived. PIP stands bewildered; this was not at all what he was expecting.

Ah! The retirement of the location reminds you of the country. It does me sir, it does me. Now, you won't want me any more –

PIP: No, thank you –

WEMMICK: But I keep the cash, Mr Pip, so we shall most likely meet pretty often. Good day.

PIP: Good day. (*He holds out his hand for a handshake, but WEMMICK has no idea what the gesture means. Then he remembers:*)

WEMMICK: Ah, yes. One so gets out of the habit. In London. Good day!

PIP, alone, puts down his suitcase and looks round at his new home.

PIP: Good. Good day…

SCENE 21

A YOUNG GENTLEMAN, laden with so many parcels that we can't initially see his face, breathless, late and busy; opening doors, organising the furniture for the scene – whatever – and all the time, talking FAST!

THE YOUNG GENTLEMAN: Mr Pip? Dear me, I am extremely sorry, I knew there was a coach from your part of the country at midday, but the fact is I have been out – not that that is any excuse – for I thought, coming from the country, you might like a little fruit, and I went to Covent Garden to get it good. Dear me! I am rather bare here, but I hope you'll be able to make out tolerably well. This is the sitting room – chairs and tables and carpet and so forth – and in there's my little bedroom, rather musty, but then Barnard's is musty – and this is yours – the furniture's hired, but if you should want anything, I'll go and fetch it, but, dear me, I beg your pardon, you're holding the fruit all this time, pray let me take it –

They finally see each other.

HERBERT POCKET: (*For it is he.*) Lord bless me – you're the prowling boy!

PIP: And you – are the pale young gentleman!

HERBERT: I say, I do hope you'll forgive me for having knocked you about so.

PIP: Oh – oh yes.

HERBERT: (*Offering his hand.*) Herbert.

PIP: (*Shaking it.*) Pip.

Without ever once stopping talking, during this next conversation HERBERT gets everything they need for dinner out of his parcels, lays the table etc – and they tuck in.

HERBERT: That was all rather a long time ago, wasn't it? I was rather on the lookout for good fortune then.

PIP: Indeed?

HERBERT: Yes, Miss Havisham had sent for me, too, to see if she could take a fancy to me. But, she couldn't. If she had, I suppose I should have been provided for – perhaps even what-d'you-called it to Estella. Affianced. What's-his-named… Engaged. Still, I didn't much care for her. She's a Tartar. You know she's been brought up by Miss Havisham to wreak revenge on all the male sex?

PIP: Revenge? What revenge?

HERBERT: Lord, Mr Pip, don't you know?

PIP: No. (*Completely absorbed, and mouth crammed with food.*)

HERBERT: Dear me, it's quite a story – which perhaps I might begin by mentioning that in London it is not the custom to put the knife in the mouth – for fear of accidents – scarcely worth mentioning, dear boy, only it's as well to do as other people do –

PIP: Thank you.

HERBERT: Quite. Well, Miss Havisham's mother died when she was a baby, and her father denied her nothing. He was

a gentleman, very rich, and excuse me for mentioning it, but Society as a body does not expect one to be so strictly conscientious in emptying one's glass as to turn it bottom upwards, Pip...

PIP: Oh. Thank you. Having been brought up in a country place, you see –

HERBERT: Quite.

PIP: Do go on.

HERBERT: – very rich, and when he died, she was left an heiress. Now I come to the cruel part of the story – merely breaking off dear Pip to observe that a dinner napkin may usefully be left on one's lap –

PIP: Sorry –

HERBERT: Not at all. So: there appeared on the scene, at the races or a ball or whatever – this is all twenty-five years ago – a man, who made love to her – a showy, not-at-all-a-gentleman sort of a person. Pursued her, professed to be devoted – and so on – and she loved him. Passionately. The marriage day was fixed, the wedding dress bought – the bride-cake ordered – the day came: but not the bridegroom. He wrote her a letter –

PIP: Which she received at twenty minutes to nine –

HERBERT: When she was dressing for the wedding – at which hour she afterwards stopped all the clocks –

PIP: – and has never since looked upon the light of day...

HERBERT: Never, dear boy.

PIP: I see. Is Estella...what relation is she?

HERBERT: None: adopted.

PIP: And what became of the man? Is he still alive?

HERBERT: I don't know. But all that I do know, you know.

PIP: And all that I know, Herbert, you know.

This last exchange is done as a toast; at the moment that their glasses clink, HERBERT suspends... PIP talks to the audience:

– he said it with so much meaning, that I felt he as perfectly understood Miss Havisham to be my benefactor as I understood the fact myself... I explained that condition on my fortune, that we must never enquire as to whom I owed it –

HERBERT: (*Cheating on the freeze.*) – Never, dear boy?

PIP: Never!

HERBERT: Never.

PIP: and then...

then...we began my life as gentleman!!

He unfreezes HERBERT with another chink of the glass. As he describes his new life, his voice gradually ascends several social registers...possibly we hear Society chattering away under the scene...

In the evening, we went walking in the lighted streets, and to the theatre –

HERBERT: Ah the theatre –

PIP: The next day, to church at Westminster Abbey –

HERBERT: Good morning!

PIP: – had luncheon –

HERBERT: Good *afternoon* –

PIP: – walked in the park, took coaches, and generally – well, generally spent an amount of money within a few short months that previously I should have thought almost fabulous.

JAGGERS: (*Who has been there for some time, listening and watching.*) I told you you'd get on well.

PIP: Mr Jaggers!

JAGGERS: Well, how much do you want this month?

PIP: I don't rightly know Mr Jaggers.

JAGGERS: Fifty pounds? Five?

PIP: Oh more than that.

JAGGERS: More than that, eh…

PIP: It is so difficult to fix a sum, Mr Jaggers. When one is a gentleman.

JAGGERS: Twice five? Three times? Four times five? Might that do?

PIP: Handsomely, I should think.

JAGGERS: Might it.

PIP: Which I suppose you might make twenty pounds.

JAGGERS: Never mind what I make of your money, my friend; what we all want to know is, what *you'll* make of it. Wemmick!

WEMMICK appears.

Pay him twenty pounds.

JAGGERS goes back where he came from; WEMMICK counts out the notes.

WEMMICK: Deep…as Australia.

He follows his master; HERBERT and PIP burst out laughing and enjoy another toast, revelling in their banknotes.

HERBERT / PIP: Australia!!

On the chink of their glasses, another freeze: a much more ominous one. Suddenly, the room is dark.

PIP: I slept well at Barnard's Inn, but sometimes, at night, I would imagine myself drifting down the river, on a strong spring tide, to the Hulks; with a ghostly pirate or…or a convict, calling out to me as I passed. I –

This is suddenly interrupted by an inexplicable knock on the door… PIP is terrified.

Who's there? Who's there!!

No answer: frightened, PIP unfreezes HERBERT with another chink of his glass, and of course HERBERT goes to see who it is at the door.

SCENE 22

HERBERT: A letter for Mr Pip.

PIP: 'My dear Mr Pip, I write this at this request of Mr Gargery, to let you know...'

JOE: (*Appears to humbly voice-over the letter, holding his best hat, and tongue-tied at the thought of addressing Pip-in-London even by letter; BIDDY is with him.*) '...to mention, Pip, Sir, that Miss A, or otherways Havisham, she wish to speak to you, sir, to tell you that which Estella has come home and would be glad to see you. Wishing you ever well and ever prospering to a greater and a greater heighth Pip old chap...'

PIP: ...dah dah dah dah...

BIDDY: 'Yours ever, Biddy.'

HERBERT: Nothing else?

PIP: (*Affecting nonchalance.*) No.

But he is lying; we hear the rest of the letter:

BIDDY: 'P S, we talk about you in the kitchen every night Pip, and wonder what you are saying and doing. Joe wishes me most particular to write *what larks*, and says he thinks you were ever that good in your heart, and God bless.'

JOE: 'God bless Pip old chap.'

PIP: (*Justifying himself, massively covering his feelings, and in his poshest voice.*) You know Herbert, sometimes I think I really should... really – (*But whatever it was he was going to say about his feelings with regard to JOE, and a plan to go and visit them one day, it is not said. Brightly:*) I really should repair to Miss Havisham's *tomorrow*, Herbert.

HERBERT: Certainly, Pip, you must.

At a command from HERBERT, in a single gesture the COMPANY remove his dressing gown, give PIP a hat and portmanteau for the journey, sweep away Barnard's Inn, and we once again see the door of Satis House looming up out of his memory.

SCENE 23

PIP: She had adopted Estella, she had as good as adopted me – it could not fail to be her intention to bring us together...

The doorbell.

SARAH: (*Older, and even greener with envy.*) You, is it.

PIP: It is, Miss Pocket.

SARAH: You know the way.

SCENE 24

MISS HAVISHAM: Come in, Pip.

MISS HAVISHAM is older. With her, there is a ravishingly elegant lady whom PIP thinks he has never seen before.

Come in come in how do you...

PIP kisses her hand.

Well?

PIP: I heard, Miss Havisham, that you were so kind as to wish me to come and see you, and have come directly.

She indicates the lady. The lady turns and looks at him. It is ESTELLA.

MISS HAVISHAM: Do you find her much changed, Pip? She was proud, and insulting, and you wanted to go away from her. Remember?

PIP: Estella?

ESTELLA: (*She laughs.*) Lord but I must have been a singular little creature to hide and see you fight that day. But I did – and I enjoyed it very much.

PIP: You rewarded me very much.

ESTELLA: Did I? I don't remember.

PIP: He and I are great friends now.

ESTELLA: Are you?

PIP: Yes. Do you also not remember that you used to make me cry?

ESTELLA: No. You see, I have no heart – if the heart has anything to do with memory.

PIP: You must give me leave to doubt that.

ESTELLA: Oh I have a heart to be stabbed in or shot at – but you know what I mean. I have no (*She echoes MISS HAVISHAM's gesture from PIP's first visit to Satis House.*) softness, here. No – sympathy. Sentiment.

PIP: Estella I –

ESTELLA: Are you scared?

PIP: I should be, if I believed you.

ESTELLA: Oh come. Don't shed any tears for my cruelty today. *Boy.*

PIP is transfixed by her all over again. As the scene slides into unreality – almost a dream sequence – ESTELLA stays as its glittering centre, and he cannot take his eyes off her. MISS HAVISHAM prowls around her prey…

MISS HAVISHAM: Do you admire her, Pip? Do you?

Love her! Love her! If she wounds you, love her; if she tears your heart to pieces, love her, love her, love her! I'll tell you what real love is. It is blind devotion, unquestioning self-humiliation, utter submission, trust and belief and giving up your heart…

They both have their hands upon their hearts now: Mother and Daughter. Mr JAGGERS has emerged from the shadows again.

PIP: Mr Jaggers, sir, may I ask you something?

JAGGERS: You may : I may decline to answer it.

PIP: Estella's name – is it Havisham, or –

JAGGERS: It is Havisham.

MISS HAVISHAM: Love her, Pip. Love her!

PIP: I do!

HERBERT: Pip, may *I* ask *you* a question?

PIP: You may.

HERBERT: Without encroaching on forbidden ground of your, well, *Expectations*, may I ask, have you any idea of Estella's views on…on this matter of your feelings for her.

PIP: I adore her.

HERBERT: Quite. But, my dear Pip I know you will abominate me, think of what she is. Think of her bringing up.

PIP: I do. And I can't help it; I love her…against reason, against promise, against peace, against hope… against happiness.

HERBERT: Quite.

MISS HAVISHAM: I raised her to be loved…

PIP: Oh they all say I'm a lucky fellow, and of course I am – yesterday I was a blacksmith's boy, and today, I am – what? What? She's still a thousand miles away from me!

HERBERT: You must bide your time…you'll be twenty-one before you know it, and then, perhaps, you'll get some further enlightenment.

PIP: Time? I know nothing of time, Herbert! Mr Jaggers!

We begin to hear the faint but growing sounds of a society ball or party – laughter, music… ESTELLA smiles.

HERBERT: Pip –

JAGGERS: How much *this* month, Mr Pip? (*He begins to count out lavish amounts of money.*)

HERBERT: You know my dear Pip, we are beginning to contract rather –

PIP: I said, I can't help it! I have Estella to think of.

MISS HAVISHAM: She has admirers without end, Pip. Without end…

As PIP grabs his money, MISS HAVISHAM maliciously opens a door…

SCENE 25

And a small collection of very drunk high-society party guests bursts in.

The rules for the whirling, nightmare choreography of this sequence are: PIP always keeps an eye on ESTELLA; ESTELLA seems to give everyone what they want, but seems always to be gliding out of reach. In the course of the scene, we should see MR DRUMMLE change from upper-class bore to drunken brute.

GUESTS: Estella!

DRUMMLE: A drink for the lady!!

(*Introducing himself to PIP.*) Drummle, Sir; Bentley Drummle. Next heir but one to a baronetcy, actually. Estella!

ANOTHER GUEST: *My* people are down in Somerset

PIP: (*To ANOTHER GUEST.*) Pirrip – but I am always called Pip. Does he know her?

ANOTHER GUEST: Never you mind…

DRUMMLE: Estella; are you well…

ESTELLA: I am; I and the jewels.

HERBERT: Pip –

PIP: What?

HERBERT: Pip, it seems to me you're spending –

PIP: I know: picnics, plays, parties; assembly balls –

ANOTHER GUEST: There's assembly balls in all *sorts* of places, these days.

ANOTHER GUEST: – concerts, fêtes – *operas*…

HERBERT: Your jeweller's account alone is one hundred and twenty-three pounds, fifteen and six –

PIP: I know! –

ANOTHER GUEST: Richmond, Hammersmith, Covent Garden –

PIP: Estella! I cannot bear to hear people saying she throws herself away on mere boors.

ANOTHER GUEST: Apparently, she can.

ESTELLA: What do you mean? (*Waving across a crowded room at MR DRUMMLE.*)

DRUMMLE: Here's to the Lady!!

PIP: Estella –

ESTELLA: Moths hover about a lighted candle, Pip. Can the candle help it?

PIP: You know he has nothing to recommend him but money.

ESTELLA: Pip, don't be foolish.

PIP: Herbert, how much do we owe now?

HERBERT: We go from bad to worse, Pip. Bad to worse.

GUESTS: Really?

PIP: (*Very drunk now, and shouting.*) It's only because that blundering brute of a Mr Bentley Drummle so hangs about her –

The party cuts; people turn and stare out his outburst:

HERBERT: I do hope, Pip, that when you *are* twenty-one, we finally find out –

PIP: (*Turning on him.*) Find out what?

HERBERT: What your 'expectations' actually are.

JAGGERS materialises.

PIP: Mr Jaggers –

JAGGERS: Congratulations, Mr Pip. Twenty-one.

Now Mr Pip. Have you anything you wish to ask me?

PIP: Of course, it would be a great relief to ask you several questions, sir –

JAGGERS: Ask one.

PIP: Is my benefactor to be made known to me today?

COMPANY: No.

JAGGERS: No. Ask another.

PIP: Is that confidence to be imparted to me soon?

JAGGERS: Another.

PIP: Have I – have I any income to receive meanwhile, sir?

JAGGERS: Five, Hundred, Pounds.

PIP: Five hundred. (*To HERBERT.*) You see, she *does* design me for Estella –

HERBERT: O Pip, Pip, will you never take warning?

PIP: Of what?

ESTELLA: Of me.

MISS HAVISHAM: See how she uses you? As she uses all the others. Does she attract, Pip? Does she *torment?*

Proprietorially, as always, she touches ESTELLA – but ESTELLA flinches away – for the first time.

ESTELLA: (*Very calmly.*) I cannot think why you should be so unreasonable, Pip. I must be taken as I have been made.

Must I not, Pip?

PIP: Why must you give to others looks and smiles, such – such as you never give to me?

ESTELLA: Do you mean, to Mr Drummle? Merely to deceive and entrap, Pip.

PIP: Do you deceive and entrap him, Estella?

ESTELLA: Yes. Mr Drummle, and many others. All of them, Pip.

All of them…*except you…*

ESTELLA smiles.

PIP: Ah!

He covers his face with his hands to blot out this memory, and the picture fades.

SCENE 26

PIP: So, twenty-one years of age, and not word to enlighten me on the subject of my great expectations. Not a word!

And Herbert was away…

To get some respite, I used to try, in the evenings, to read. (*A book is thrown at him, and he catches it.*) Some old Eastern stories… In one of them, a great slab of stone is to fall on a bed of state, at the very moment of amorous conquest. (*PIP tells the story with relish, as if it was about somebody else.*) The heavy slab is slowly wrought out of the quarry; the tunnel for the rope to hold it in its place, slowly carried through leagues of rock; the slab raised and fitted in the ceiling, and the rope riven to it. The fatal hour come, the sultan is aroused in the dead of the night, and the sharpened axe that was to sever the rope put into his hand. The blow is struck – the rope parts and rushes away – and the great heavy slab –

A light has begun to grow behind PIP's door. From the shadows, the COMPANY is watching him. He thinks he hears something on the stairs – but it is nothing.

I'm sorry.

I couldn't stop thinking about her you see. It was a wretched night, stormy and wet – with the wind, rushing up from the river – and I can remember –

Now he's starting to get alarmed.

thinking of Joe, and Biddy –

when all the lights blew out.

The sound of the wind out on the marshes. PIP picks up his lamp.

PIP: Who's there?

Who do you want?

COMPANY: Pip.

PIP: That is my name. What's the matter?

COMPANY: Nothing.

The same door that first revealed MAGWITCH once again swings open. A MAN walks slowly into the light; he has long grey hair. He holds out his hands.

PIP: Explain yourself!!

THE MAN WITH GREY HAIR: My, how you've grow'd up, Pip.

PIP realises who it is.

PIP: Ah!

MAGWITCH: You acted noble, my boy. Noble! And I have never forgot it.

PIP: Keep off! If you are grateful to me for what I did when I was a little child, I hope you have shown your gratitude by mending your way of life; now, surely, you must understand – that – that I –

MAGWITCH: You was saying?

PIP: That I cannot wish to renew that chance intercourse with you under these very different circumstances. Our ways…have been different ways. Will you drink something before you go?

MAGWITCH: I think I will.

PIP pours him a drink – which MAGWITCH drinks exactly as he did the brandy, out on the marshes. When he puts the empty glass down, he has made up his mind to speak.

I've been away in the new world. Where I has done well.

PIP: I am glad to hear it.

MAGWITCH: And has you? Done well I mean.

PIP: Wonderfully well.

MAGWITCH: May I make so bold as ask you *how*?

PIP: How?

I was…was chosen. To succeed to some property?

MAGWITCH: Might a mere warmint ask, what property.

PIP: I don't know.

MAGWITCH: Might a mere warmint ask, whose?

PIP: I – I don't know.

MAGWITCH: Could I make a guess, I wonder, at your income since you come of age. As to the first figure, now. Would it be a Three?

COMPANY: Or a Four?

Or a Two?

MAGWITCH: Or would it be a Five?

PIP: What?

MAGWITCH: And as to the first letter of the lawyer's name who paid it…

Would it be a J?

A gun booms out on the marshes, echoing in PIP's memory; he staggers.

Yes, Pip dear boy. It's me wot made a gentleman on you. I lived rough, that you should live smooth – I put money away, only for you to spend –

Someone pours PIP a brandy, and as he greedily takes it, whispers in his ear.

COMPANY: He's your second father, Pip!

Having done their damage, they exit.

PIP: No!

MAGWITCH: – And now look at you. A lord, eh? A lord!

Didn't you never think it might be me?

PIP: Never. Never.

MAGWITCH: Well it wos me – and single-handed. Never a soul in it but my own self and Jaggers.

PIP: Was there no one else?

MAGWITCH: No – who else should there be?

As if stabbed, PIP turns away –

PIP: Estella!!

He recovers himself.

What's your name?

MAGWITCH: Magwitch. Chris'ened Abel.

PIP: And how is it you know Jaggers?

MAGWITCH: First know'd Mr Jaggers in court. He was for me, last time I was tried.

PIP: What were you tried for?

MAGWITCH: What I done, is worked out and paid for!

And now, dear boy, where will you put me?

PIP: Put you?

MAGWITCH: I must be put somewheres.

PIP: My friend and companion is absent – you must have his room, here –

MAGWITCH: He won't come back?

PIP: No not until tomorrow

MAGWITCH: Because I aren't safe; it's death, if I'm took.

PIP: What do you mean, death?

MAGWITCH: I was sent for life, and it's death, to come back. It weren't easy, dear boy –

PIP: Stop! Listen, I can't think. You must – you must sleep.

MAGWITCH: I must, dear boy – sleep long and sound. Sea-tossed and sea-washed, I've been, for months – dreaming of sleep… of sleeping on a gentleman's linen, dear boy…

As MAGWITCH drifts off into sleep, PIP tries desperately to think what to do to escape from this nightmare.

PIP: Jaggers!

He locks the door behind him, and runs.

SCENE 27

PIP runs through the city at night to find MR JAGGERS.

SCENE 28

JAGGERS: Now, Pip; be careful! Don't commit yourself.

PIP: I merely want, Mr Jaggers, to assure myself that what I have been told, is true.

JAGGERS: Did you say 'told'? 'Told' would seem to imply verbal communication, and you can't have verbal communication with a man in New South Wales you know.

PIP: Then I will say, informed, Mr Jaggers –

JAGGERS: Good.

PIP: – Informed by a person, named Abel Magwitch, that he is the benefactor so long unknown to me.

JAGGERS: That is the man.

PIP: And only he.

JAGGERS: And only he.

PIP: I am not so unreasonable, sir, as to think you at all responsible for my mistakes, but I had always supposed it was Miss Havisham.

JAGGERS: As you say, Pip, I am not at all responsible for that.

PIP: And yet it looked so like it, sir.

JAGGERS: Pip, take nothing on its looks. There's no better rule. (*He hands over some papers.*) The full balance of your expectations. There is still...still some balance remaining.

Good night, Pip.

SCENE 29

PIP returns to Barnard's, unlocking the door. MAGWITCH is asleep. PIP is staring at him, feeling himself drawn back into his nightmare, when he starts and wakes.

MAGWITCH: Ha! It does me good fur to look at you, Pip. A gentleman, eh? The real genuine One... I'll show them – I'll show them a better gentleman than the whole kit of them out together. There's enough in that –

PIP: We need to know what is to be done. To know how you are to be kept out of danger.

MAGWITCH: Without I am informed agen, that danger ain't so great.

PIP: Is there no chance person who might identify you?

MAGWITCH: There ain't many...one. One person.

PIP: Who?

MAGWITCH: That black betraying beast I was with the day I first see my boy. Name of Compeyson...

PIP: Is he still alive?

MAGWITCH: ...I did think when I came in at your stairs last night, there was a person, maybe, alonger me – watching...

PIP: Then where are you to live? How am I to keep you safe?

MAGWITCH: Dear boy –

They are stopped by a sound on the stairs; MAGWITCH gets his knife out.

HERBERT: Pip my dear fellow how are you – honestly I seem to have been gone a twelvemonth Pip my dear – Hulloa!

PIP: Herbert, something very strange has happened. This is – a visitor of mine.

MAGWITCH: (*Producing a Bible.*) Take it in your right hand. Lord strike you dead, if you ever split in any way sumever. Kiss it!

PIP: Do as he wishes, Herbert.

He does.

HERBERT: Pip –

PIP holds out his hand and stops him; then says to the audience:

PIP: I recounted the whole of the secret.

HERBERT: (*Sitting down in astonishment.*) I see. Well! – and this man we think might have been seen on the stairs –

MAGWITCH: – that man you first see with me a-pounding of his scarred face in that ditch on the meshes –

PIP: – Compeyson –

HERBERT: – well in view of him, the first and main thing that is to be done, I suppose, is to get your…visitor…out of England. You will have to go with him, of course.

MAGWITCH: Dear boy?

PIP: (*Lying.*) Yes. Yes, of course.

But I must see Estella first…

SCENE 30

A nightmare of doors; he knocks at the first one.

MAID: I'm afraid Miss Estella is now residing in Richmond, sir.

Another door.

ANOTHER MAID: I'm afraid Miss Estella has gone into the country.

PIP: Where, in the country?

THIS OTHER MAID: Satis House, sir. The name is Hebrew, I believe. Or Greek: it means that whoever –

PIP: Thank you.

> I couldn't – obviously – couldn't stay with Joe and Biddy, so I
> had the coach drop me at the Blue Boar. It was a whimpering,
> shivering morning –
>
> *Another door; and who should be coming out of it, but –*

BENTLEY DRUMMLE: Oh! Just come down?

PIP: Yes.

DRUMMLE: Your part of the country, I believe.

PIP: Yes. Staying long, Mr Drummle?

DRUMMLE: Can't say. Do you?

PIP: Can't say.

DRUMMLE: Thought I might go for a ride, later; explore the
marshes. Quaint out-of-the-way villages, they tell me. Curious
little public houses. *Smithies*, and that. Waiter!

WAITER: Sir?

DRUMMLE: Bring that horse round would you – oh – and I won't
dine. Dining at the lady's, you see.

WAITER: Very good sir.

DRUMMLE: Did you get that? At the lady's.

WAITER: Yes sir.

DRUMMLE: Good morning.

PIP: Brute.

> *The door of Satis House.*
>
> Oh, if I had never entered it. Never seen it…
>
> *The doorbell, echoing.*

SCENE 31

MISS HAVISHAM, with ESTELLA.

MISS HAVISHAM: And what wind blows you here, Pip?

Well?

PIP: Tell me, when you first caused me to be brought here, Miss Havisham, did I really come as any other chance boy might have come: as a whim.

MISS HAVISHAM: You did.

PIP: Did Mr Jaggers –

MISS HAVISHAM: Mr Jaggers had nothing to do with it. His being my lawyer, and the lawyer of your patron, is a coincidence.

PIP: But when I fell into the mistake – ha! – the *mistake* I have so long remained in, at least you will admit you led me on.

MISS HAVISHAM: Yes.

PIP: Was that kind?

MISS HAVISHAM: Who am I, who am I, for God's sake, that I should be kind?

PIP: In humouring my mistake, Miss Havisham –

MISS HAVISHAM: You made your own snares. *I* never made them –

PIP: – you made me believe that you meant…that you meant us (*ESTELLA looks at him.*) …for one another.

Estella, you know I love you – indeed, have loved you ever since I first saw you in this house. Now, I know – I know. I know that I have no hope of ever calling you mine, Estella. But still –

ESTELLA: (*Cutting him off, but very calmly.*) When you say you love me, I know what you mean, as a form of words; but nothing more. You address nothing, here. I have tried to warn you of this, have I not?

PIP: Yes.

ESTELLA: Yes. But you would not be warned.

PIP: Estella, is it true that Mr.Bentley Drummle is in town here, and pursuing you, and that you…that you encourage him?

ESTELLA: Quite true.

PIP: You cannot love him, Estella…

ESTELLA: (*Angrily.*) What have I told you?

PIP: You would never marry him?

ESTELLA: Why not?

Why not, Pip? I am tired of the life I lead, and I wish to change it. I am going to be married to him.

PIP: He is a mean, stupid brute…

ESTELLA: Don't be afraid of my being a blessing to him. I shall not be that.

PIP: O Estella… (*He weeps, and turns away.*)

ESTELLA: Come! (*She holds out her hand for him.*) This will pass in no time…

PIP: Estella…

ESTELLA: …You will get me out of your thoughts in a week.

PIP: (*'In an ecstasy of unhappiness'.*) Never. Never! God forgive you! God bless you and forgive you…

Brushing aside MISS HAVISHAM, and unseen by PIP, ESTELLA goes.

Out of my thoughts! She was in every line I had ever read; in every prospect I had ever seen since first I came to that dreadful house as a poor, coarse, common boy; she was in the river, in the darkness…in the wind…

MISS HAVISHAM: Gone, Pip. Gone!

PIP: All gone! All done – and never, never…… never!

Seeing him weep, for the first time, MISS HAVISHAM turns on PIP a ghastly stare of pity and remorse. She seems to reach out to him – but the scene ends.

SCENE 32

A BOY: Sir?

PIP: What?

BOY: A note, sir. And the messenger that brought it said, would you be so good as to read it out here on the street, sir.

PIP: Wemmick's handwriting…

COMPANY: Don't. Go. Home.

PIP: Why not?

WEMMICK: I accidentally heard, sir, yesterday morning…

PIP: What?

WEMMICK: That a certain person, not altogether of uncolonial pursuits – let us not name him – having disappeared from one place, and now being in another, was being watched.

PIP: By whom?

WEMMICK: I couldn't go into that. That question might clash with official responsibilities. I couldn't *say*, sir. Couldn't *say*…

PIP: (*Understanding WEMMICK's hint.*) I see. Then let me ask you: Have you ever heard talk of a man with a scar on his face, whose name is Compeyson?

WEMMICK: (*Nods.*)

PIP: Is he living?

WEMMICK: (*Nods.*)

PIP: Is he in London?

WEMMICK: (*Nods.*)

PIP: I must find Herbert –

WEMMICK: Mr Pip, I will tell you something. Mr Herbert has already removed a certain person, sir, to a house with a bow window, which house is down by the riverside, sir.

PIP: The river?

WEMMICK: Which house is very well thought of, for the following reason, which is to say that if after a while, and when it might be thought prudent, a certain person might want to slip, or be slipped, let's say, on board a foreign packet boat –

PIP: Where is it?

WEMMICK: (*Handing him a card.*) Down on the Pool between Limehouse and Greenwich. Don't break cover too soon, Mr Pip…

PIP: (*Reading the card.*) Mill Pond Bank, Chink's Basin. A queer old house –

SCENE 33

MAGWITCH is asleep behind a locked door; they whisper so as not to wake him.

HERBERT: All is well; he's quite safe – though eager to see you.

PIP: I don't like to leave him here…though I suppose he's safer here than near me.

HERBERT: When the time comes, we can take him down the river ourselves. Now go, before he wakes up –

PIP: Dear Herbert – goodnight.

PIP alone.

I couldn't get rid of the notion of being watched.

I practised, on the river, and we waited. And waited.

Waited.

Out on that dark water, how many undesigning persons I suspected of being him, it would be hard to calculate. It was the strangest thing: I kept seeing him – with his scar – just here. It was if I had shut an avenue of a hundred doors to keep him out, and then –

A door opens – but it is only JAGGERS.

JAGGERS: A note, Pip. Sent up to me by Miss Havisham, telling me that she wishes to see you.

(*As PIP reads it.*) When might you think of going down?

PIP: I have an impending engagement, that renders me rather uncertain of my time… At once, I think.

JAGGERS: What's the matter?

PIP: Shall we say, Mr Bentley Drummle, Mr Jaggers? Goodnight.

PIP hurries away.

JAGGERS: So Mr Drummle won, did he? I wonder if he'll beat her…

SCENE 34

PIP discovers that the door of Satis House has been left open and unlocked. Finding no servant, he goes in search of MISS HAVISHAM.

He finds her sitting by her fire; old, and with an air of utter loneliness upon her.

She thinks he is a ghost.

MISS HAVISHAM: Is it real?

PIP: It is I, Miss Havisham. Pip. Mr Jaggers gave me your note.

MISS HAVISHAM: Thank you. Thank you.

I want… I want to show you that I am not all stone.

Do you hate me?

PIP: No. No.

MISS HAVISHAM: O! What have I done? What have I done…?

PIP: Miss Havisham I should have loved her anyway –

MISS HAVISHAM: She is married! What have I done…? Pip – my dear – believe me, when she first came to me, I meant to save her – save from misery like my own, no more – but she grew; grew so beautiful…and so I stole her heart away…

PIP: Miss Havisham, when she first came here –

MISS HAVISHAM: It was Jaggers brought her. Asleep…a little girl, for me to *love*… I called her Estella.

PIP: Whose child was she?

MISS HAVISHAM: She was only two or three… Jaggers tells me you are in debt. If I give you money, your mind will be more at rest…

PIP: Miss Havisham –

MISS HAVISHAM: Take it! I have written my name at the top of the paper. If ever you could write, under my name there, 'I forgive her' – Pip – if ever you could write that…then take the pencil, and write…write…

PIP prises himself away, and shuts the door behind him. He reads the paper she has given him, lost in thought.

SCENE 35

From behind the door, a terrible scream. PIP tears it open, and sees MISS HAVISHAM running towards him, a whirl of fire blazing all about her… As she burns, he tries to smother the flames. Even when they are all out, he will not let go of her.

The COMPANY are there with him.

PIP: I held her as tight as I could…

A BYSTANDER: The surgeon's coming sir..

PIP: But it was hopeless – No! Don't move her!

BYSTANDER: Sir…

They get her out of his arms.

PIP: Everything, burnt. They laid her out on the table – where she'd told me she'd lie.

A COMPANY MEMBER: (*Who played MISS HAVISHAM.*) 'Take the pencil, and write under her name – I forgive…'

PIP: I'll do it – give me a pencil –

But his hands are too badly burnt to even hold a pencil – he cries out in pain. They get him into a chair, and HERBERT comes out of the COMPANY to look after him.

SCENE 36

PIP: Herbert! Is all well down by the river?

HERBERT: Sit still, Pip. All is well… (*As he cleans and bandages his hands.*) He's been telling me all about his wild dark life.

Did I hurt you?

PIP: No.

HERBERT: Shall I tell you, or would it worry you just now?

PIP: Tell me, by all means.

HERBERT: Seems that your…visitor…and some troublesome woman, had a little child, a little child of whom he was exceedingly fond…but the woman was a young woman, and a jealous woman, and a revengeful one…to the last degree.

PIP: What last degree?

HERBERT: To murder – but Mr Jaggers defended her and got her off. After the acquittal, she disappeared…and thus he lost both the child's mother and the child…of whom he was so fond… Mr Jaggers had her into care somewhere I think.

PIP: (*Flinching and pulling away.*) When did this happen? Tell me every word he said.

HERBERT: (*Alarmed by this reaction, checking PIP's brow for fever.*) He said around a score of years ago…some three or four years before he come upon you in the churchyard. He said you brought into mind the little girl so tragically lost. She would have been about your age, he said.

PIP: Herbert, look at me.

HERBERT: I do look at you, my dear.

PIP: I am not in any fever, nor is my head that much disordered by last night's accident.

HERBERT: N-no; you are rather excited, but quite yourself.

PIP: I know I am quite myself. And that man we have in hiding down by the river, is Estella's father.

The click of a door closing. JAGGERS, with WEMMICK in attendance and laden with legal papers, is in the room.

JAGGERS: Does he know? Magwitch, does he know it?

PIP: No. I think he has no knowledge his daughter is still in existence.

JAGGERS: Hah! Good. Good.

Now, Mr Wemmick; what item was it we were at? –

He intends to leave, but PIP stops him.

PIP: Sir! Surely, if her father is still alive –

JAGGERS: Mr Pip! Mr Pip let me put a case to you. Let me put the case that a woman – an absconding, violent sort of a woman – left the fate of her child to her legal adviser. Put the case that that same legal adviser held a trust to find a child for a certain eccentric rich lady to adopt and bring up.

PIP: I follow you.

JAGGERS: I admit nothing!

PIP: No sir.

JAGGERS: Put the case that that lawyer lived in an atmosphere of evil, and that pretty nigh all he saw of children, was, their being generated in great numbers for certain destruction. For neglect. For prison. For being made orphans, Pip.

PIP: Sir.

JAGGERS: And now put the case Pip that here was one child out of the whole heap who could be saved. As to whom, over the mother, that legal adviser had the power to say, I know what you did, and how you did it, now give me that child.

Put the case that the child then grew up, and was married for money.

Now put the case that the father was still living, but that the secret of the child's parentage was still a secret. Put that last case to yourself very carefully.

PIP: I do.

JAGGERS: For whose sake would you reveal it? I hardly think it would serve her, to establish her parentage for the information of her new – and rich – husband, after an escape from shame for nigh on twenty years!

Adding, of course, to the case, that you loved her.

WEMMICK: A man can't help his feelings Mr Jaggers.

JAGGERS: His *what*, Mr Wemmick?

Well Mr Pip, your verdict?

WEMMICK, suitably admonished, advises PIP to silence by putting his fingers on his lips. So does HERBERT. So, eventually, does PIP.

Quite. Now, Wemmick, what item was it we were at, before coming to call on Mr Pip here?

WEMMICK: An elder daughter taken on suspicion of shoplifting, Mr Jaggers...

JAGGERS: Ah yes...

They exit in a flurry of legal papers '...with an air of refeshment on them, as if they had just had lunch'.

SCENE 37

HERBERT: Well, are your hands sufficiently better to handle an oar do you think?

PIP: Yes Herbert.

HERBERT: Shall you go with him?

PIP: Yes.

HERBERT: Where?

PIP: Hamburg, Rotterdam – I think any foreign steamer that will take us out of England will suffice, don't you?

They shake hands – and we hear the sounds of the river. A steamer sounding its foghorn…

During this next sequence, HERBERT and PIP's text and actions are urgent, anxious and afraid; the COMPANY, meanwhile, are entirely detached both in the way they move and speak.

PIP: Passports?

HERBERT: Passports.

PIP: Oars?

HERBERT: Oars – and the tide turns in half an hour.

PIP: Right.

They unlock a door, and quickly organise MAGWITCH, coats and bags.

COMPANY: At that time, the steamer for Hamburg started from the Pool of London at about nine o'clock, on a Thursday morning.

Meaning it was due to pass Gravesend at just after one o'clock.

The tide began to turn down at nine, and would be with them until gone twelve.

MAGWITCH: (*As he is handed into the boat.*) My dear boy; my faithful, dear boy.

COMPANY: It was one of those days when the sun shines hot and the wind blows cold.

The sunlight, dancing on the river, freshened them with new hope, and they soon passed out of the Pool and left the barges and colliers and traders behind.

They were sure they were not being followed.

PIP: Pull easy, Herbert.

COMPANY: But of course, they could no more see to the bottom of the next few hours than they could see to the bottom of the Thames.

They reached Gravesend –

Right out in the marsh country –

The tide was still with them, and running strong.

PIP: Easy…

COMPANY: But then, at ten minutes to one…

HERBERT: Is that a boat?

PIP: There's her smoke…she's going at full speed: pull hard, Herbert.

The sound of the steamer's paddles.

COMPANY: They were so busy getting their bags ready –

And saying goodbye –

HERBERT: Dear Pip –

COMPANY: That neither of them saw a four-oared galley shoot out from under the river bank a little way ahead of them, with a man at its helm with a blanket wrapped over his face.

HERBERT: What?

COMPANY: Coming head on at them.

The panic begins: the noise of the steamer begins to rise to a deafening crescendo.

PIP: Keep us on the tide!

A MAN WITH A MEGAPHONE: You have a returned transport there. His name is Abel Magwitch. I apprehend that man, and call upon him to surrender.

PIP: Keep down…

A VOICE ON THE STEAMER: Ahoy there!

PIP: Ahoy! Here!

HERBERT: Pip!

VOICES: Stop the paddles!! Stop them!

HERBERT: They're running aboard us!

VOICES: Stop!!!!

Suddenly, the hideous cacophony of the paddles does stop, leaving just the gentle sound of the river. Events slide into a dreadful slow-motion.

PIP: Both boats were swinging round with the force of the tide, and on board the steamer, all hands were running frantically forward:

I saw the steersman of the galley lay his hand on his prisoner's shoulder. As he did it, I saw his face. It was –

COMPEYSON: (*In sneering, vindictive triumph.*) It was the face he remembered from the marshes. With the scar: just here. (*To MAGWITCH.*) Come on then: murder me.

MAGWITCH takes him by the throat.

PIP: I saw the face tilt backwards with a white terror on it I shall never forget, and then –

PIP, MAGWITCH and COMPEYSON are plunged into the water.

PIP is the first to emerge – desperately fighting for breath –

Herbert was there –

HERBERT: Pip! Where is he?

PIP: But they – they were gone…

A desperate silence as they scan the water…

A VOICE: There!

PIP: A dark object, bearing towards us on the tide.

MAGWITCH is hauled out of the water; he has gone under the steamer-paddles, and his ribs are broken. PIP takes him in his arms and tries to make him comfortable.

I'm so sorry. If you hadn't come back for me –

MAGWITCH: Dear boy. I'm quite content. I've seen my boy…and he can still be a gentleman without me.

PIP: I will never leave you. I will be as true to you, as you have been to me!

MAGWITCH: Thank'ee, dear boy, thank'ee. God bless you. Never?

PIP: Never. Are you in much pain?

MAGWITCH: I don't complain, dear boy. I don't complain.

He dies in PIP's arms.

PIP: No!

As they did with MISS HAVISHAM, someone tries to take PIP away from the body.

A DOCTOR: Mr Pirrip, sir –

PIP: No – there's something I have to tell him.

Magwitch, that child you once had, the child you loved and lost…she lived. She lived, and found powerful friends. She is…a lady, and very beautiful. And I…I loved her… O Lord, be merciful to him, a sinner.

PIP refuses to be comforted. One of the COMPANY becomes JOE.

JOE: Here, let me try.

SCENE 38

PIP recognises the hand on his shoulder.

PIP: Joe?

JOE: Which it air, old chap.

PIP: O Joe, look angry at me. Strike me. Tell me of my ingratitude. Why are you all so good to me?

JOE: Dear old Pip old chap, you and me was ever friends.

PIP: But Joe –

JOE: Why go into subjects, old chap, which betwixt two sech must now be for ever onnecessary? Whatsumer the failings on our part, we remember, you was that good in your hart – eh, Pip.

PIP: Have you heard, Joe? Who my patron was?

JOE: I heerd as it were not Miss Havisham, old chap.

PIP: My expectations are quite dissolved Joe. Quite dissolved.

JOE: Yes, old chap.

PIP: In fact, I'm ashamed to tell you what I have come down to. I'm –

SARAH: He's One Hundred and Twenty-three Pounds, Fifteen and Six in debt! To a jeweller's! The very *idea*!

BIDDY: All paid, Pip – here's the receipt.

SARAH: Oh!

PIP: Biddy? – I never meant…

BIDDY: Yes, Pip? What did you never mean?

A beat.

PIP: Biddy, thank you for all you have done for me, and I have so ill repaid. Can you forgive me?

JOE: Dear old Pip old chap, there has been larks, but what have been betwixt us, have been, and God knows as we forgive you.

BIDDY: Amen.

MR WOPSLE: Amen! – Amen indeed – Behold: The Reward of Ingratitood… Ha!

A furious exit.

MR PUMBLECHOOK: Young man, I am sorry to see you brought low, but what else could be expected – eh, ladies and gentlemen? What else could be expected?

Exit.

Exit JOE and BIDDY, as a married couple.

Exit, after one last look, the actor who played MAGWITCH.

HERBERT: Are you sure you don't still fret for her Pip?

PIP: Oh no…

HERBERT: Tell me… Have you quite forgotten her?

PIP: That dream has all gone by Herbert, I assure you. All gone by.

HERBERT: Well… I'm very much afraid I must go, too. Goodbye, Pip.

SCENE 39

PIP alone.

PIP: Forgotten…?

I had forgotten nothing.

Not the door; not the house, not those endless dark passages and stairs…nor the boy I once was, when I was first led down them. I could trace out every part of it.

But – well, there is no house now – no door – nothing. Nothing left at all…

The stage is very empty.

It was eleven years before I went back. I told Biddy I was going to see the churchyard, but even as I said it, I knew that it was the site of the old house I wanted to see. The cleared space had been enclosed with a rough fence, and I could see that some of the old ivy had struck root anew, and was growing green on the ruins. The gate in the fence had been left standing ajar, and so I pushed it open. The moon was coming out, and there was just enough light to see –

She is there.

ESTELLA: Pip.

She is older, and changed.

I wonder you know me.

Silence.

PIP: Do you often come back?

ESTELLA: I have never been here since… Since.

PIP: Nor I.

ESTELLA: Are you well?

PIP: Yes. Living abroad, working pretty hard for a living… I still have debts to pay, you see.

ESTELLA: I have often thought of you.

PIP: Have you?

ESTELLA: Very often.

Pip, you once said to me, 'God bless you, God forgive you.' If you could say that to me then, surely you can say it again now.

He does not.

Now, when suffering has been stronger than all other teaching… When it has taught us…when it has taught me to understand what your heart used to be.

Tell me we are friends. Tell me.

Carefully, silently, just as they did when PIP's throat was first grabbed by MAGWITCH, the COMPANY peer round and through the seven doors, wanting to see what will happen next. As they wait to hear PIP's answer, we hear the sound of MAGWITCH's file echoing on the marshes…

FIN